W9-AWU-789

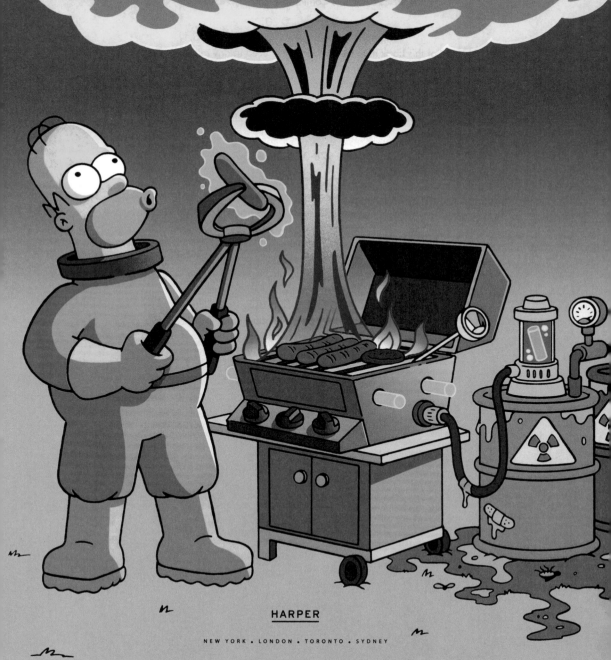

SIMPSONS COMICS
MELTDOWN

HARPER

NEW YORK · LONDON · TORONTO · SYDNEY

The Simpsons TM, created by Matt Groening, is the copyrighted
and trademarked property of Twentieth Century Fox Film Corporation.
Used with permission. All rights reserved.

SIMPSONS COMICS MELTDOWN

Collects Simpsons Comics 91, 92, 93, 94, and 95

Copyright © 2011
Bongo Entertainment, Inc. All rights reserved.
No part of this book may be used or reproduced in any manner whatsoever
without written permission except in the case of brief quotations
embodied in critical articles and reviews. For information address
HarperCollins Publishers,
10 East 53rd Street, New York, NY 10022.

FIRST EDITION

ISBN 978-0-06-203653-7

11 12 13 14 15 QG 10 9 8 7 6 5 4 3 2

Publisher: Matt Groening
Creative Director: Bill Morrison
Managing Editor: Terry Delegeane
Director of Operations: Robert Zaugh
Art Director: Nathan Kane
Art Director Special Projects: Serban Cristescu
Production Manager: Christopher Ungar
Assistant Art Director: Chia-Hsien Jason Ho
Production/Design: Karen Bates, Nathan Hamill, Art Villanueva
Staff Artist: Mike Rote
Administration: Ruth Waytz, Pete Benson
Intern: Max Davison
Legal Guardian: Susan A. Grode

Printed by Quad/Graphics, Inc., Montreal, QC, Canada. 06/25/11

SIMPSONS COMICS

Meltdown

CONTENTS

100% FISSION FRESH!

:YAWN!:

FIRST DIBS ON THE BATHROOM!

WHAT?

WAIT! I LEFT MY TEETH WHITENING STRIPS IN TOO LONG!

I NEED TO BRUSH THEM OFF MY TEETH BEFORE THEY BLEACH THE REST OF MY HEAD!

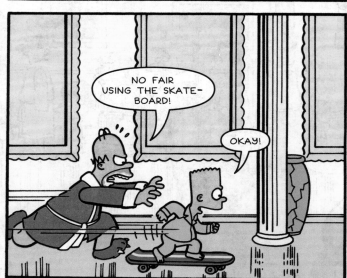

NO FAIR USING THE SKATE-BOARD!

OKAY!

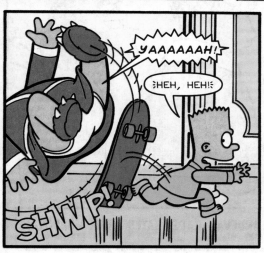

YAAAAAAH!

:HEH, HEH!:

SHWP!

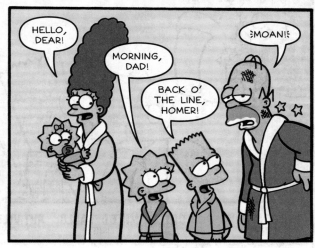

HELLO, DEAR!

MORNING, DAD!

BACK O' THE LINE, HOMER!

:MOAN!:

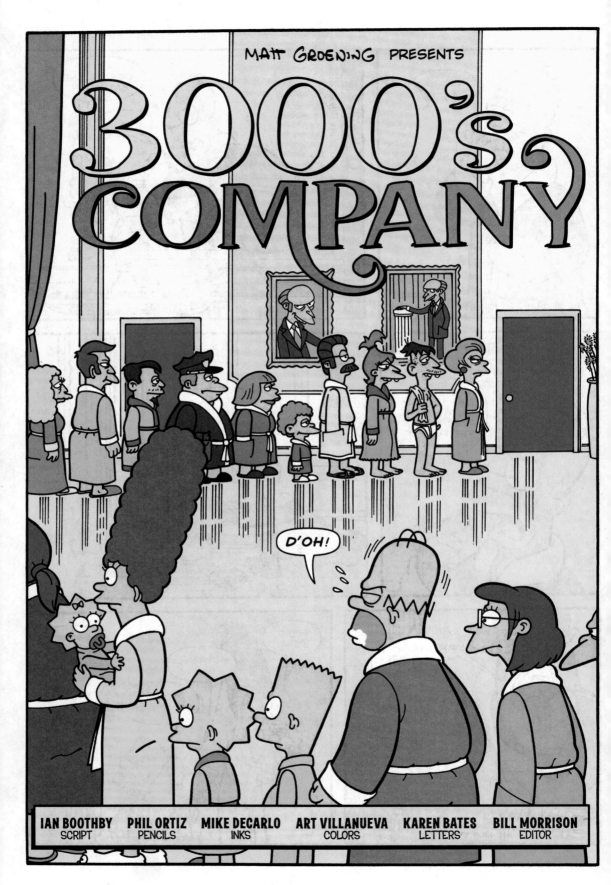

ONE WEEK EARLIER...

"COMING THIS FALL! THEY'RE FOUR *SEXY* WOMEN OUT TO MARRY SPRINGFIELD'S *MOST ELIGIBLE BACHELOR!*"

"BUT HE'S GOT A *SECRET!*"

THANKS, BUT I'M JUST NOT INTERESTED!

IT'S NOT *YOU*, IT'S *ME!*

"*JOE SURPRISE!* THURSDAYS AT NINE!"

EWW...

CUT! I SAY, WELL DONE EVERY- ONE!

MR. BURNS, I JUST DON'T FEEL COMFORTABLE WITH THIS.

PISH TOSH! THIS *DECLAN DESMOND* FELLOW HAS AGREED TO FILM THE PROGRAM HERE AT THE NUCLEAR PLANT.

WE NEED SOME TELEVISION COVERAGE THAT *ISN'T* A "60 MINUTES" EXPOSÉ!

WHAT? *MIKE WALLACE?!* YOU'RE STILL *EMBEDDED* HERE?

YES! NOW EITHER COME CLEAN ABOUT YOUR CRIMES AGAINST THE ENVIRONMENT OR FLUFF MY PILLOW!

BAD NEWS, CHAPS. THE NET- WORK HAS CUT OUR SHOW FROM THE FALL LINE-UP.

⋮WHEW!⋮

WHAT? WHY?

FLUFF!

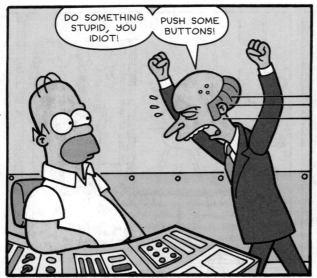

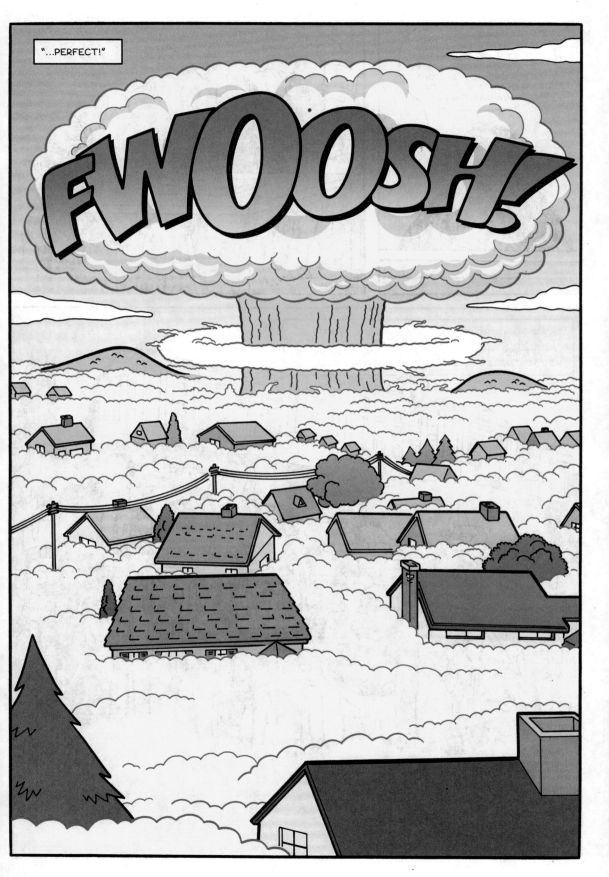

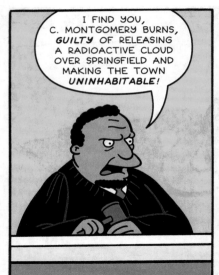

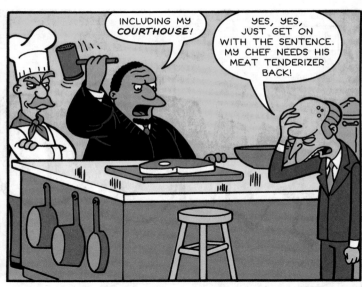

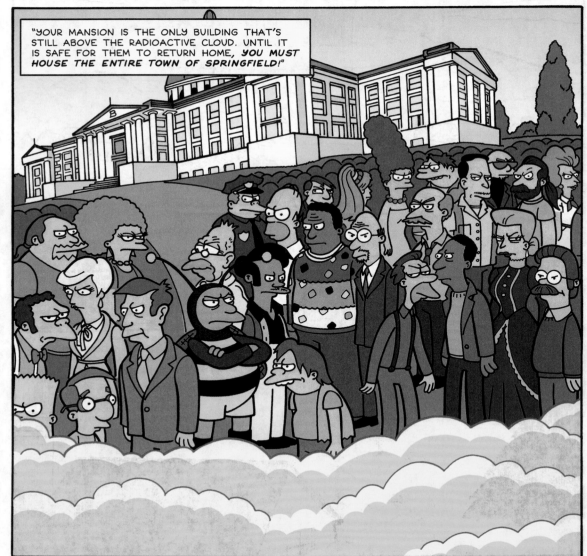

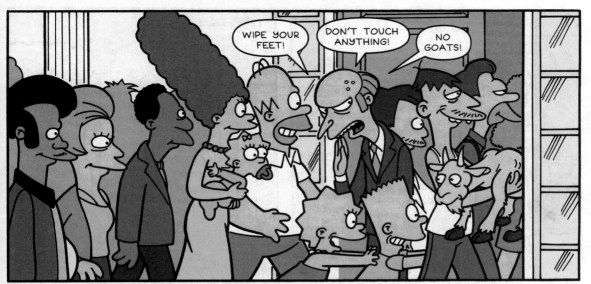

WIPE YOUR FEET!

DON'T TOUCH ANYTHING!

NO GOATS!

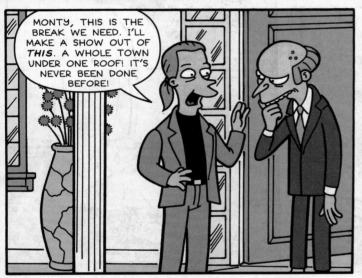

MONTY, THIS IS THE BREAK WE NEED. I'LL MAKE A SHOW OUT OF *THIS*. A WHOLE TOWN UNDER ONE ROOF! IT'S NEVER BEEN DONE BEFORE!

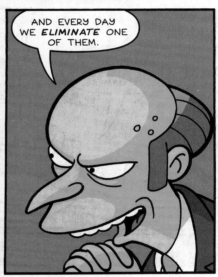

AND EVERY DAY WE *ELIMINATE* ONE OF THEM.

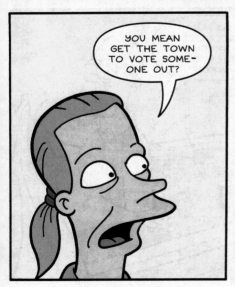

YOU MEAN GET THE TOWN TO VOTE SOME- ONE OUT?

I *MEANT* HUNT THEM FOR SPORT.

BUT WE'LL PLAY IT YOUR WAY.

FOR NOW.

AND SO...

IT'S MORNING IN THE MANSION THAT I'VE VERY CLEVERLY DUBBED THE "TOWN" HOUSE! LET'S LOOK IN ON A TYPICAL FAMILY.

GAME ROOM

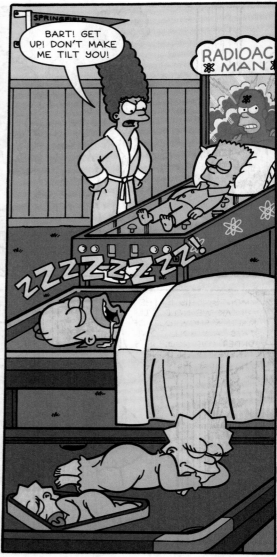

BART! GET UP! DON'T MAKE ME TILT YOU!

RADIOAC MAN

ZZZZZZZZ!!

MOAN! JUST LET ME SLEEP TWO MORE GAMES!

RADIOACTIVE MAN

RADIOACTIVE

MOM, I THINK MAGGIE'S STUCK!

SUCK! SUCK!

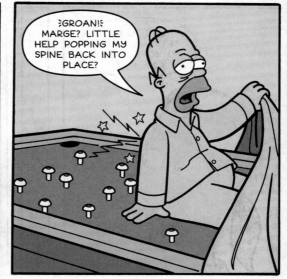

GROAN! MARGE? LITTLE HELP POPPING MY SPINE BACK INTO PLACE?

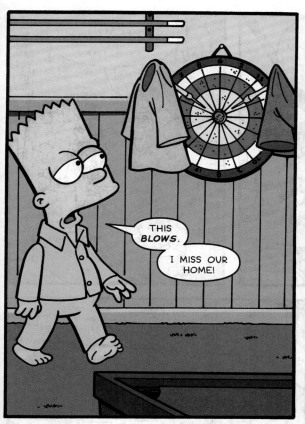

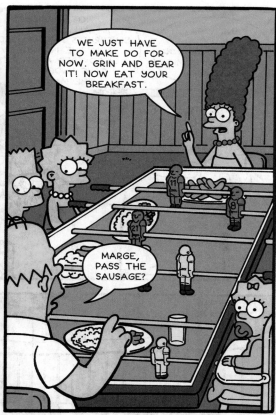

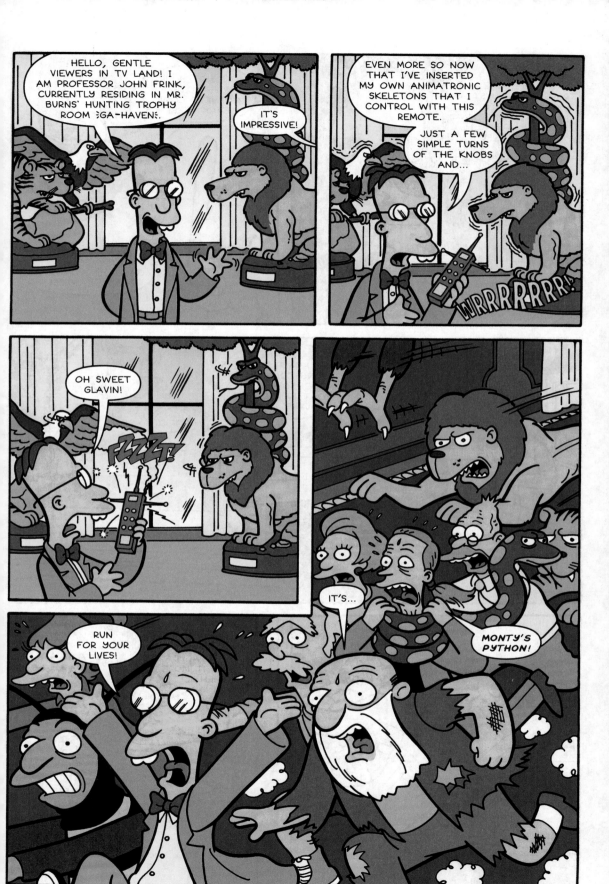

HONESTLY, MOTHER, STOP SETTING THESE TRAPS. I WAS JUST GOING OVER TO EDNA'S ROOM!

I DON'T CARE IF YOU *ARE* ENGAGED. I WON'T HAVE ANY OF THOSE SHENANIGANS UNDER MY ROOF!

IT'S NOT YOUR ROOF, MOTHER! *MOTHER?* COME BACK HERE!

WOW! SOME-ONE LEFT A *PIÑATA* HANGING HERE!

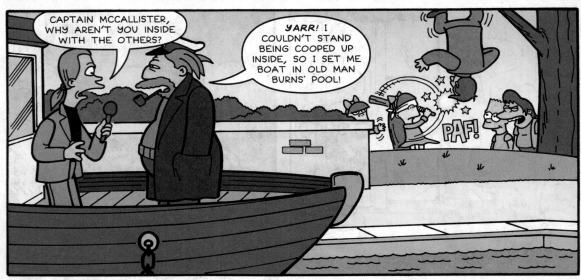

CAPTAIN McCALLISTER, WHY AREN'T YOU INSIDE WITH THE OTHERS?

YARR! I COULDN'T STAND BEING COOPED UP INSIDE, SO I SET ME BOAT IN OLD MAN BURNS' POOL!

PAF!

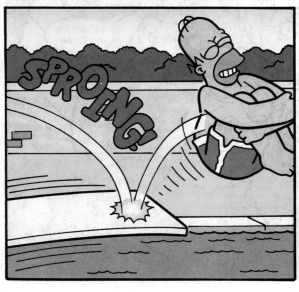

SPROING

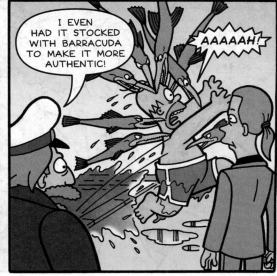

I EVEN HAD IT STOCKED WITH BARRACUDA TO MAKE IT MORE AUTHENTIC!

AAAAAH!

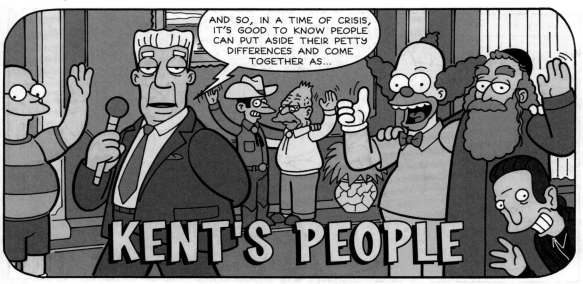

AND SO, IN A TIME OF CRISIS, IT'S GOOD TO KNOW PEOPLE CAN PUT ASIDE THEIR PETTY DIFFERENCES AND COME TOGETHER AS...

KENT'S PEOPLE

SHOVE OFF, MATE! *I'M* DOING THE HUMAN INTEREST STORIES ON THIS SIDE OF THE STREET!

MAKE ME!

AND ON THE *LIGHTER SIDE,* YOUR GIRLY PUNCHES *TICKLE!*

POW!

SOCK!

THIS JUST IN, MY *MIC* IN YOUR *FACE!*

WHAT THE...?

WHAT HAPPENED TO THE LIGHTS?

TENANTS OF BURNS MANOR, TO SAVE MONEY THERE WILL BE ROLLING BLACKOUTS IN THE MANSION. ALSO THERE WILL BE NO POWER ON THE WEEKENDS.

CLICK!

YOUR BENEVOLENT SLUMLORD, MR. BURNS, THANKS YOU FOR YOUR COMPLIANCE.

LATER THAT NIGHT...

OH FOR CRYING OUT LOUD! IT'S BAD ENOUGH THAT THERE'S NO HEAT AND I HAVE TO SLEEP WITH MEL FOR WARMTH WITH HIS BONE POKING ME ALL NIGHT!

THAT *IS* YOUR *BONE*, RIGHT?

FOR THE LAST TIME, *YES!*

BUT THIS IS TOO MUCH! KEEP IT DOWN!

BANG!

BANG!

YEAH, KNOCK IT OFF!

NO CAN DO! I GOT THE MUSIC IN MY SOUL AND A BATTERY-POWERED AMP!

WE DIDN'T WANT TO DO THIS, BUT YOU'VE LEFT US NO CHOICE.

THIS IS HIGHLY INSULTING TO BOTH ME *AND* THE WORLD OF JAZZ.

WHICH BRINGS US BACK TO THE PRESENT...

THERE'S NO MORE WATER! THE PLUMBING'S DRIER THAN A STEVEN WRIGHT MONOLOGUE!

WE'LL DIE OF THIRST!

NO WE *WON'T!*

THERE'S STILL THE POOL WATER!

FORGOT ABOUT THE BARRACUDAS, HUH, DAD?

YEAH, YEAH...

WE DEMAND *POWER!*

AND *WATER!*

AND *FOOD!*

I WISH I COULD HELP, BUT THERE'S NOTHING I CAN DO.

AND BY "CAN DO" I MEAN "FEEL LIKE DOING!"

LOOK AT YOU, JUST A FEW DAYS WITHOUT HEAT AND FOOD AND YOU FALL APART LIKE SWEDISH FURNITURE!

NOW, CRAWL BACK TO YOUR HOLES AND MAYBE, JUST *MAYBE,* YOU'LL GET SOME CRUMBS TO EAT.

GET HIM!

I THINK NOT, MY GOOD RABBLE ROUSER!

RELEASE THE HOUNDS, SMITHERS!

YOU CUT OFF *THEIR* WATER, TOO, SIR. THE HOUNDS ARE TOO THIRSTY TO ATTACK.

THEN GO TO PLAN B!

THERE *ISN'T* ONE. WE HAD TO CUT BACK EXPENSES ON ALL YOUR PLANS TO JUST *A'S* WHEN YOUR DOT COM COMPANY FOLDED, SIR.

ONLY ONE HIT AGAIN TODAY AT SEXYMONTYPICS.ORG. I DON'T KNOW HOW YOU CONVINCED ME TO SET THIS SITE UP, SMITHERS.

I'M SURE THAT ONE SURFER IS VERY LOYAL, SIR.

YAAAAAAAA!

WAIT! WAIT! *THIS* AIN'T RIGHT!

WHAT DO YOU MEAN, MOE?

IT AIN'T A *REAL* ANGRY MOB WITHOUT PITCHFORKS AND TORCHES!

THERE YA GO! NO SHOVING! WE GOT LOTS!

ACME ANGRY MOB TORCHES *and* PITCHFORKS

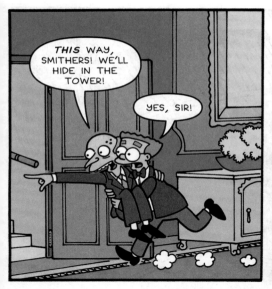

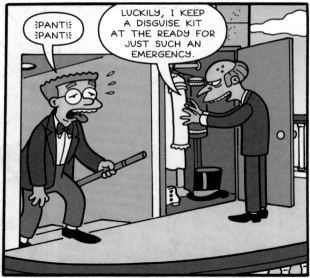

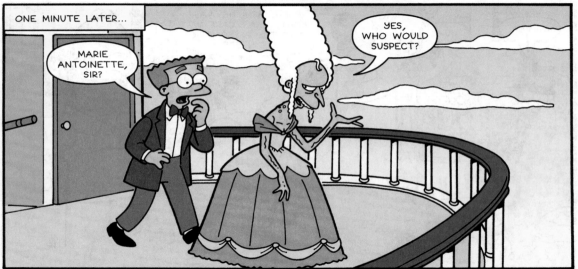

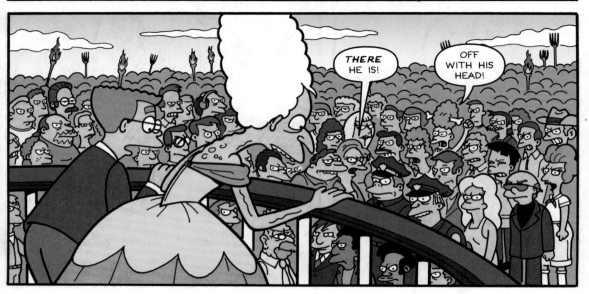

THEY'VE SEEN THROUGH MY BRILLIANT DISGUISE!

PERHAPS A BRIBE!

HERE, WHY ATTACK WHEN I'LL LET YOU EAT CAKE!

MMMMM!

YUM!

HEH, HEH! HE WAS RIGHT, THAT CAKE WAS JUST THE PRESCRIPTION WE NEEDED!

YOU KNOW, I WAS TOO WEAK TO *REALLY* STORM THE MANSION, BUT THAT CAKE HAS GIVEN ME THE *QUICK ENERGY* I NEED!

LET'S *GET* HIM!

CURSE YOU, BETTY CROCKER! THE OLD GYPSY *SAID* YOU'D BE MY DOWNFALL!

28

WAIT! STOP!

TOO HIGH A VOICE FOR ALLAH, MUST BE VISHNU!

I'VE BEEN TO THE TOWN!

BUT IT'S RADIOACTIVE! SHE'S POISONED!

BURN HER!

NOT BEFORE SHE BITES ME AND GIVES ME SUPER-POWERS!

EWWWW!

I DIDN'T THINK THE CLOUD LOOKED RIGHT AND WITH SOME HELP FROM PROFESSOR FRINK WE RAN SOME TESTS.

IT TURNS OUT ¦GA-HEY!¦ THE GAS ISN'T RADIOACTIVE, BUT A SERIES OF FOG MACHINES SPEWING AN ALOE VERA-BASED MIST! WITH THE SOFTNESS AND THE LUBRI-*CATION*!

FSSSST

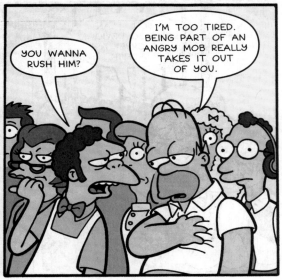

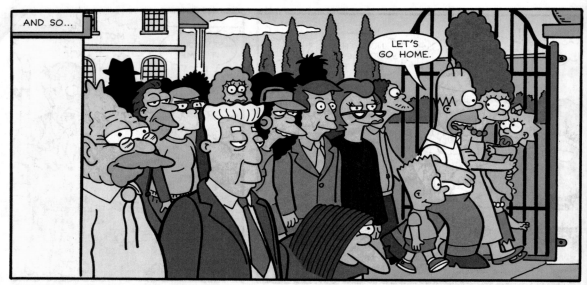

AND SO...

LET'S GO HOME.

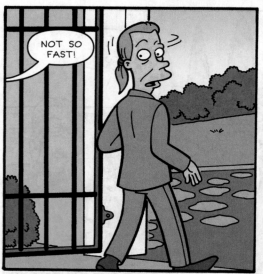

NOT SO FAST!

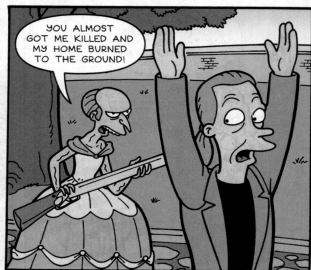

YOU ALMOST GOT ME KILLED AND MY HOME BURNED TO THE GROUND!

YOUR PLAN WAS SO DEVIOUS, SO CRUEL AND SELFISH...

...THAT I JUST CAN'T STAY MAD AT YOU.

WELL, IF YOU'RE NOT GOING TO KILL ME, I DO HAVE *ANOTHER* SHOW IDEA I WANT TO RUN BY YOU.

Springfield Idol

♪ ...THAT IN THE SPRING...BECOMES ...THE ROSE! ♪

THAT WAS THE *BOMB*, DOG!

I LOVE IT. I FELT IT. IT *MOVED* ME!

THE LAST NOTE WAS A G-FLAT. IT SHOULD HAVE BEEN A G-*SHARP*!

RELEASE THE HOUNDS!

I SMELL A HIT!

AND THE SPCA DOESN'T MIND YOU USING THE HOUNDS?

NO, THE ONLY *CRUELTY* IS TO THE *CONTESTANTS*.

GROWL!

BARK!

SNARL!

MONITOR

GENTLEMEN, A TOAST...TO THE *EVILS* OF REALITY TV!

AAAAH!

NOW *THERE'S* THAT G-SHARP!

CLINK!

THE END

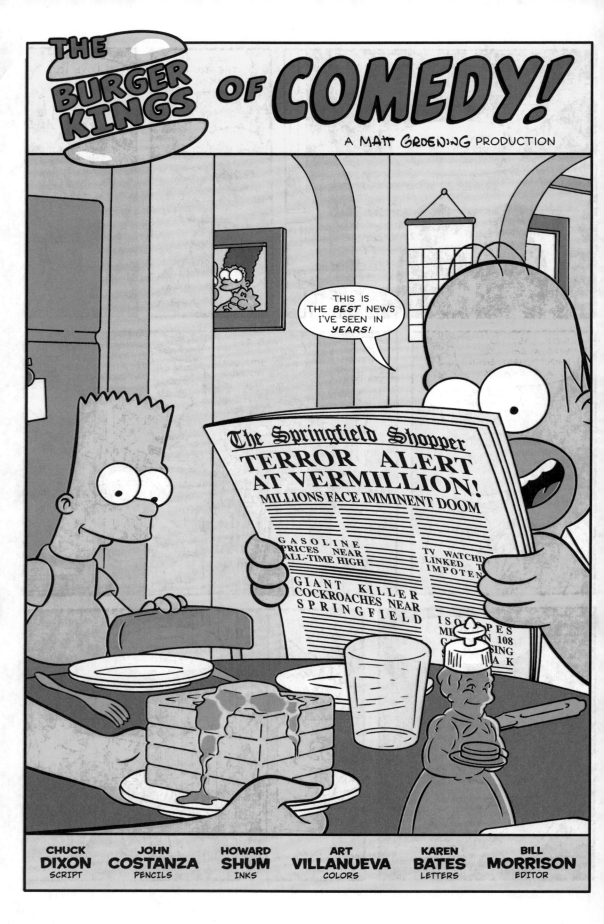

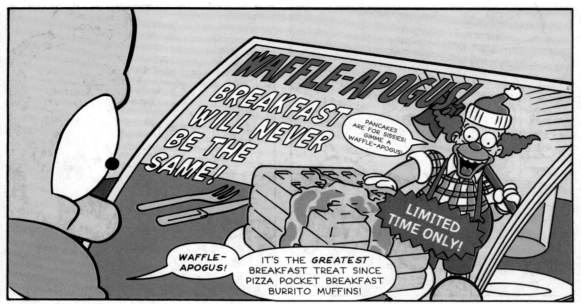

WAFFLE-APOGUS!
BREAKFAST WILL NEVER BE THE SAME!

PANCAKES ARE FOR SISSIES! GIMME A WAFFLE-APOGUS!

LIMITED TIME ONLY!

WAFFLE-APOGUS!

IT'S THE *GREATEST* BREAKFAST TREAT SINCE PIZZA POCKET BREAKFAST BURRITO MUFFINS!

MMM... WAFFLES.

I JUST *GAVE* YOU WAFFLES, HOMER. THEY'RE RIGHT IN *FRONT* OF YOU.

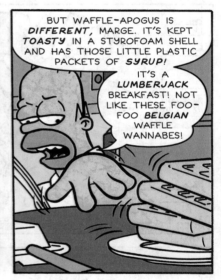

BUT WAFFLE-APOGUS IS *DIFFERENT*, MARGE. IT'S KEPT *TOASTY* IN A STYROFOAM SHELL AND HAS THOSE LITTLE PLASTIC PACKETS OF *SYRUP!*

IT'S A *LUMBERJACK* BREAKFAST! NOT LIKE THESE FOO-FOO *BELGIAN* WAFFLE WANNABES!

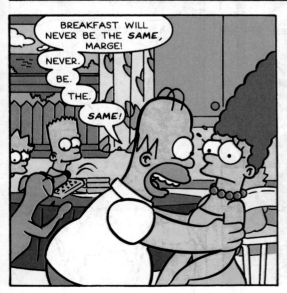

BREAKFAST WILL NEVER BE THE *SAME*, MARGE!

NEVER.

BE.

THE.

SAME!

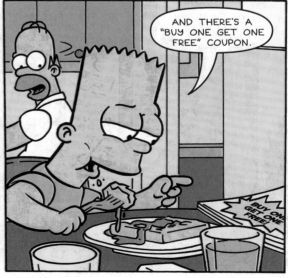

AND THERE'S A "BUY ONE GET ONE FREE" COUPON.

BUY ONE GET ONE FREE!

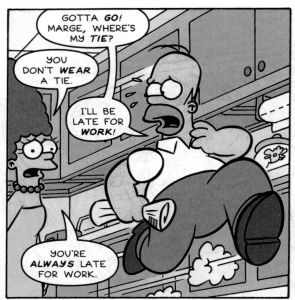

GOTTA *GO!* MARGE, WHERE'S MY *TIE?*

YOU DON'T *WEAR* A TIE.

I'LL BE LATE FOR *WORK!*

YOU'RE *ALWAYS* LATE FOR WORK.

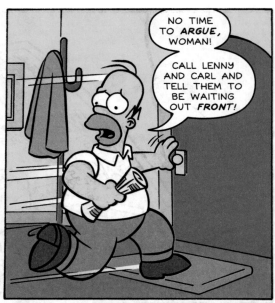

NO TIME TO *ARGUE,* WOMAN!

CALL LENNY AND CARL AND TELL THEM TO BE WAITING OUT *FRONT!*

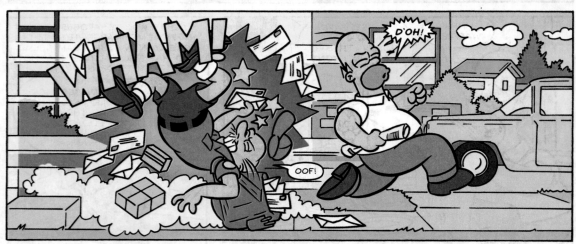

WHAM!

D'OH!

OOF!

I'M SORRY. MY HUSBAND'S EXCITED ABOUT A NEW ITEM DOWN AT *KRUSTY-BURGER.*

WHAT'S *WITH* THE PEOPLE ON THIS ROUTE? I GOT *ANOTHER* GUY OBSESSED WITH *SANDWICHES* TWO BLOCKS OVER.

WAFFLE-WAFFLE-WAFFLE!

ARE YOU HURT?

I'D *SAY* ONLY MY PRIDE...

...BUT I'M A *MAIL-MAN.*

A MAILMAN WITH A GARAGE FULL OF AMMO.

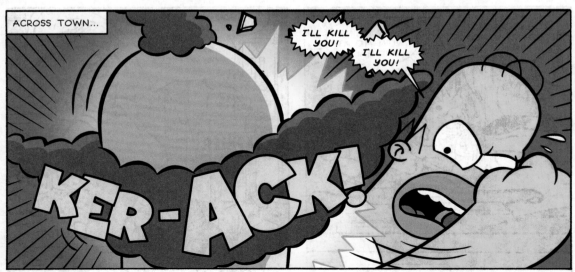

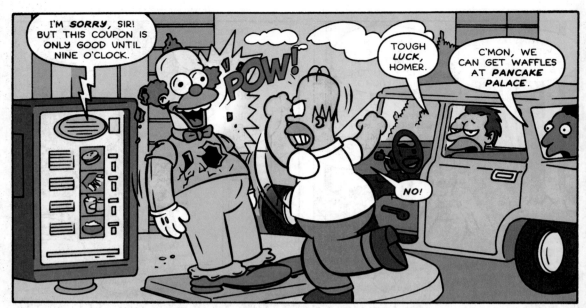

I'M *SORRY*, SIR! BUT THIS COUPON IS ONLY GOOD UNTIL NINE O'CLOCK.

POW!

TOUGH *LUCK*, HOMER.

C'MON, WE CAN GET WAFFLES AT *PANCAKE PALACE*.

NO!

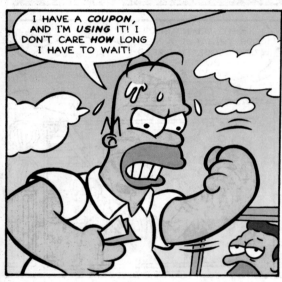

I HAVE A *COUPON*, AND I'M *USING* IT! I DON'T CARE *HOW* LONG I HAVE TO WAIT!

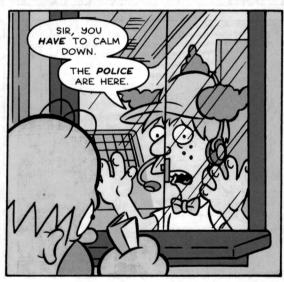

SIR, YOU *HAVE* TO CALM DOWN.

THE *POLICE* ARE HERE.

IT *NEVER* FAILS. I *ALWAYS* PULL IN BEHIND SOMEONE WITH A BIG ORDER.

SAME THING WITH *ME* AT THE BANK.

GRRRR!

AS GOD IS MY *WITNESS*... ...I'LL NEVER GO HUNGRY FOR *WAFFLES* AGAIN!

CASHIER

I'M *THROUGH* BEING PUSHED AROUND! YOU *HEAR* ME?

YEAH, BUT WHAT CAN THE LITTLE MAN *DO*?

CARL'S *RIGHT*. IT'S NOT LIKE YOU CAN *CHANGE* ANYTHING.

OH YEAH?

SOMETIMES ALL IT TAKES IS *ONE* MAN TO MAKE A DIFFERENCE...LIKE IN THAT *MOVIE* WHERE ONE MAN MAKES A DIFFERENCE.

I'LL BEAT THAT CLOWN AT HIS OWN *GAME*...

SOON...

YOU WANT TO BUY A *FRANCHISE*, MR SIMPSON?

DARN *TOOTIN'*.

KRUSTYCO INTERNATIONAL

I SEE YOU'VE *MORTGAGED* YOUR HOUSE...

...FOR THE *SIXTEENTH* TIME.

AND CASHED IN YOUR *LIFE* INSURANCE AND YOUR CHILDREN'S *COLLEGE* FUND AND ANY FUTURE EARNINGS FROM THE TOOTH FAIRY.

THREE KIDS, STILL WITH *BABY* TEETH, SIR.

WELL, ALL *LOOKS* TO BE IN ORDER.

SO, I HAVE MY *OWN* KRUSTY-BURGER?

YOU NEED TO GO TO THE *KRUSTY KULINARY INSTITUTE* FIRST.

I NEED TO *LEARN* STUFF?

SURE. ALL ABOUT MEAT PATTIES AND FRENCH FRIES AND THE PROPER RATIO OF LARD TO CHOCOLATE IN A KRUSTYSHAKE AND...

GAAHHH... LARD...

AT SPRINGFIELD ELEMENTARY...

NOW WITH 20% MORE KID PER CLASS!

"WHAT DID *YOU* BRING FOR LUNCH, LISA?"

ORGANIC ALFALFA SPROUTS AND BEAN CURD HUMMUS ON A BULGAR WHEAT CROISSANT.

WHAT ARE *YOU* GUYS EATING?

A MR. TEENY BURGER.

A DELICIOUS CHOCOLATE KRUSTYSHAKE.

SIDESHOW FRIES.

HUH?

MCBAIN VII: LICENSE TO GRILL!

BUT WHERE DID YOU--?

OH NO!

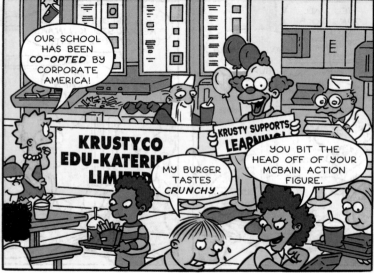

OUR SCHOOL HAS BEEN *CO-OPTED* BY CORPORATE AMERICA!

KRUSTYCO EDU-KATERING LIMITED

KRUSTY SUPPORTS LEARNING!

MY BURGER TASTES *CRUNCHY*.

YOU BIT THE HEAD OFF OF YOUR MCBAIN ACTION FIGURE.

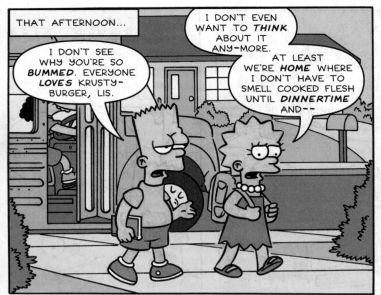

THAT AFTERNOON...

I DON'T SEE WHY YOU'RE SO *BUMMED*. EVERYONE *LOVES* KRUSTY-BURGER, LIS.

I DON'T EVEN WANT TO *THINK* ABOUT IT ANY-MORE. AT LEAST WE'RE *HOME* WHERE I DON'T HAVE TO SMELL COOKED FLESH UNTIL *DINNERTIME* AND--

NO! IT CAN'T BE!

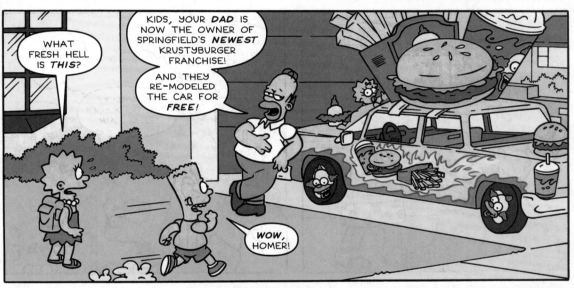

WHAT FRESH HELL IS *THIS*?

KIDS, YOUR *DAD* IS NOW THE OWNER OF SPRINGFIELD'S *NEWEST* KRUSTYBURGER FRANCHISE!

AND THEY RE-MODELED THE CAR FOR *FREE*!

WOW, HOMER!

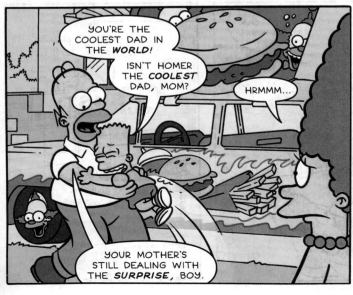

YOU'RE THE COOLEST DAD IN THE *WORLD*!

ISN'T HOMER THE *COOLEST* DAD, MOM?

HRMMM...

YOUR MOTHER'S STILL DEALING WITH THE *SURPRISE*, BOY.

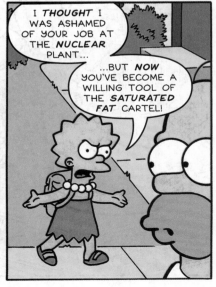

I *THOUGHT* I WAS ASHAMED OF YOUR JOB AT THE *NUCLEAR* PLANT...

...BUT *NOW* YOU'VE BECOME A WILLING TOOL OF THE *SATURATED FAT* CARTEL!

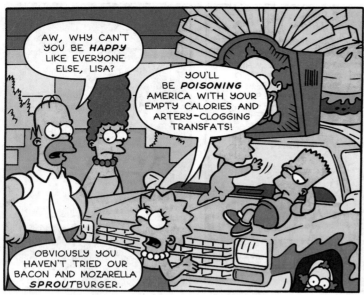

42

WHAT IS IT *NOW,* MR. SIMPSON?

THIS MOVIE IS *STUPID!* THIS *MANUAL* IS STUPID!

AND I SUPPOSE YOU ALREADY *KNOW* ALL THIS?

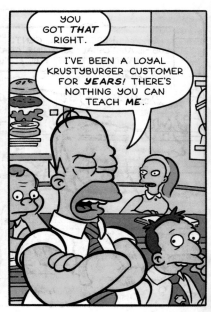

YOU GOT *THAT* RIGHT.

I'VE BEEN A LOYAL KRUSTYBURGER CUSTOMER FOR *YEARS!* THERE'S NOTHING YOU CAN TEACH *ME.*

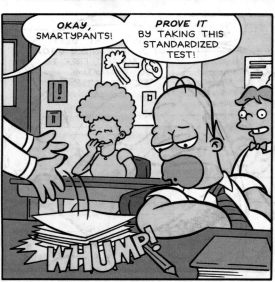

OKAY, SMARTYPANTS!

PROVE IT BY TAKING THIS STANDARDIZED TEST!

WHUMP!

MINUTES LATER...

...HM...MM... UM...

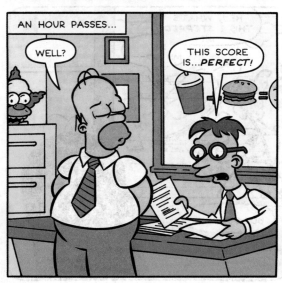

AN HOUR PASSES...

WELL?

THIS SCORE IS...*PERFECT!*

I'VE NEVER SEEN ANYTHING *LIKE* IT. YOU'RE *BORN* KRUSTY-BURGER MATERIAL, MR. SIMPSON.

WOO-HOO!

WHEN DO I GET MY *RESTAURANT?*

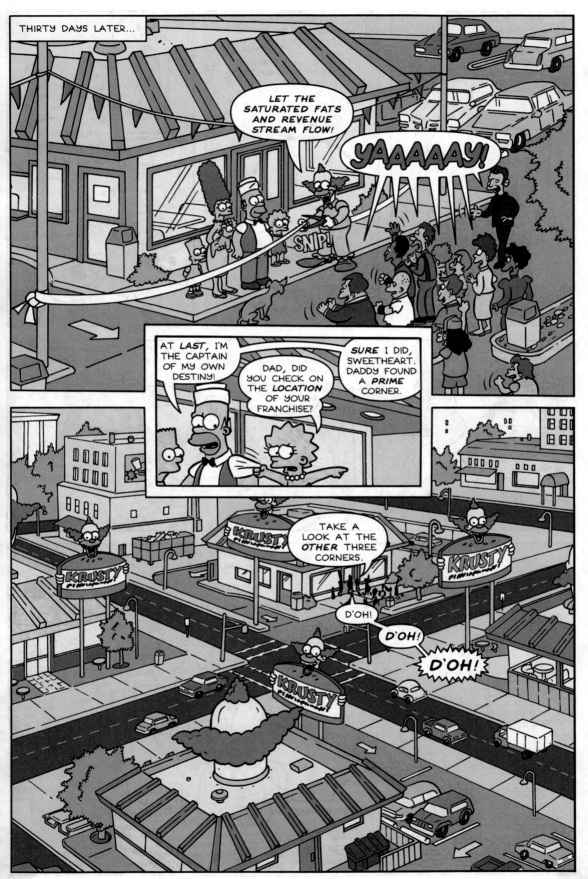

45

BUT YOUR PLACE COULD BE *BETTER* THAN THE KRUSTY'S ON THE OTHER CORNERS.

NO IT *CAN'T*, MARGE!

GRAND OP

THAT'S JUST THE *DEFEATEST* IN YOU TALKING.

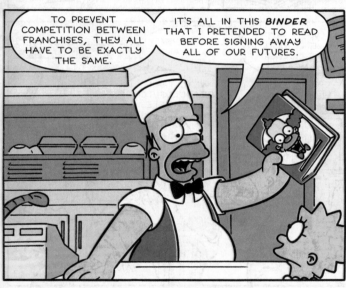

TO PREVENT COMPETITION BETWEEN FRANCHISES, THEY ALL HAVE TO BE EXACTLY THE SAME.

IT'S ALL IN THIS *BINDER* THAT I PRETENDED TO READ BEFORE SIGNING AWAY ALL OF OUR FUTURES.

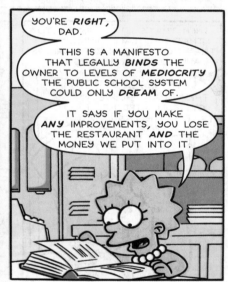

YOU'RE *RIGHT*, DAD.

THIS IS A MANIFESTO THAT LEGALLY *BINDS* THE OWNER TO LEVELS OF *MEDIOCRITY* THE PUBLIC SCHOOL SYSTEM COULD ONLY *DREAM* OF.

IT SAYS IF YOU MAKE *ANY* IMPROVEMENTS, YOU LOSE THE RESTAURANT *AND* THE MONEY WE PUT INTO IT.

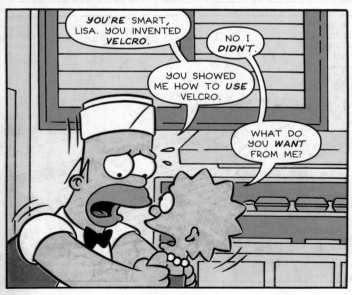

YOU'RE SMART, LISA. YOU INVENTED *VELCRO*.

NO I *DIDN'T*.

YOU SHOWED ME HOW TO *USE* VELCRO.

WHAT DO YOU *WANT* FROM ME?

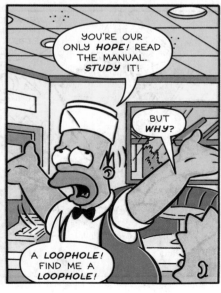

YOU'RE OUR ONLY *HOPE*! READ THE MANUAL. *STUDY* IT!

BUT *WHY*?

A *LOOPHOLE*! FIND ME A *LOOPHOLE*!

47

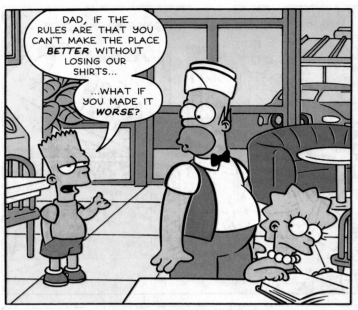

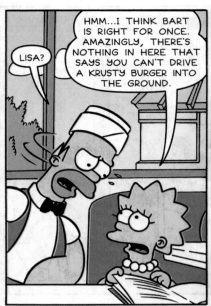

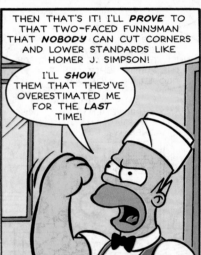

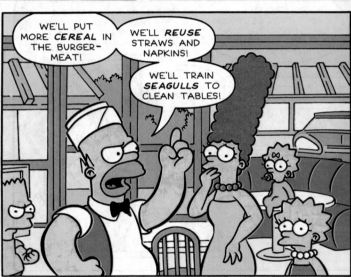

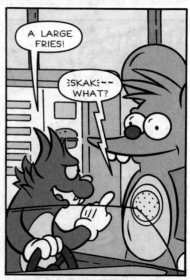

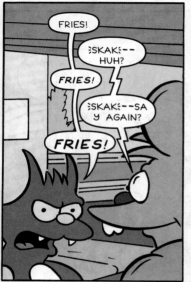

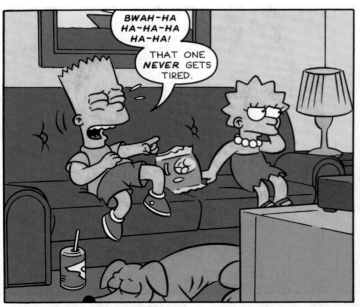

BWAH-HA HA-HA-HA HA-HA!

THAT ONE *NEVER* GETS TIRED.

HEY, I THOUGHT THAT WAS ONE OF YOUR *FAVES*, LIS.

RECENT EVENTS HAVE CAUSED ME TO LOSE MY ZEST FOR LIFE.

WHATEVER.

♪DING DONG!♪

I'LL GET IT.

HUH?

LUNCHLADY DORIS? WHAT ARE *YOU* DOING HERE?

THE SCHOOL BOARD *FIRED* ME WHEN THE CLOWN TOOK OVER THE CAFETERIA.

BUT I GOT A JOB WITH KATIE KATE KOSMETICS, SO I'M *STILL* IN THE ANIMAL BY-PRODUCTS BUSINESS.

I THINK I MAY BE ABLE TO *HELP* YOU.

BY *ORDERING* SOME LADY BOTOX WRINKLE-RECTIFIER?

NOT *EXACTLY*...

LATER...

SO, WHAT MAKES YOU THINK *YOU'RE* KRUSTYBURGER MATERIAL?

HELP WANTED

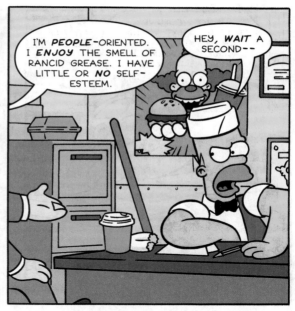

I'M *PEOPLE*-ORIENTED. I *ENJOY* THE SMELL OF RANCID GREASE. I HAVE LITTLE OR *NO* SELF-ESTEEM.

HEY, *WAIT* A SECOND--

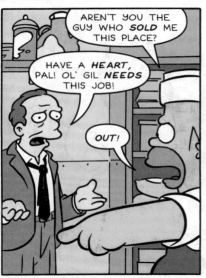

AREN'T YOU THE GUY WHO *SOLD* ME THIS PLACE?

HAVE A *HEART,* PAL! OL' GIL *NEEDS* THIS JOB!

OUT!

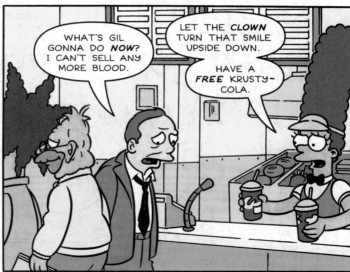

WHAT'S GIL GONNA DO *NOW*? I CAN'T SELL ANY MORE BLOOD.

LET THE *CLOWN* TURN THAT SMILE UPSIDE DOWN.

HAVE A *FREE* KRUSTY-COLA.

FREE *SODA*? THAT'S SUPPOSED TO MAKE THINGS *BETTER*?

CRUSH!

GIL *NEVER* GETS A BREAK.

$5 MILLION DOLLAR WINNER! YOU'RE THE

WHO WOULD'VE THOUGHT THAT RUNNING A *CRUMMY* RESTAURANT WOULD BE AS MUCH WORK AS RUNNING A *GOOD* ONE!

I NEED TO FIND AN EMPLOYEE WHO SHARES MY CRAPPY VISION BEFORE I--

I UNDERSTAND YOU HAVE AN *OPENING.*

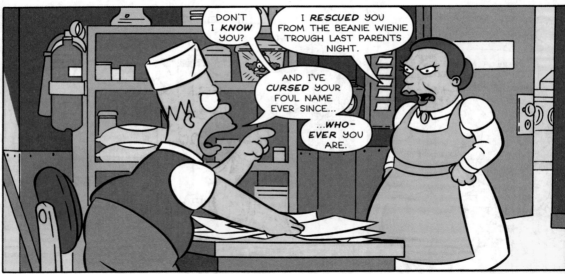

DON'T I *KNOW* YOU?

I *RESCUED* YOU FROM THE BEANIE WIENIE TROUGH LAST PARENTS NIGHT.

AND I'VE *CURSED* YOUR FOUL NAME EVER SINCE...

...*WHO-EVER* YOU ARE.

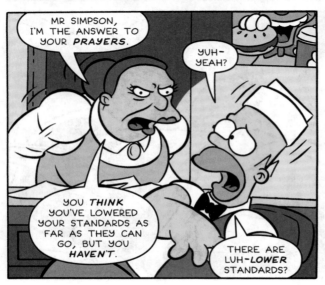

MR SIMPSON, I'M THE ANSWER TO YOUR *PRAYERS.*

YUH-YEAH?

YOU *THINK* YOU'VE LOWERED YOUR STANDARDS AS FAR AS THEY CAN GO, BUT YOU *HAVEN'T.*

THERE ARE LUH-*LOWER* STANDARDS?

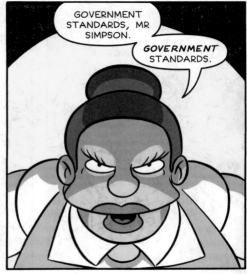

GOVERNMENT STANDARDS, MR SIMPSON.

GOVERNMENT STANDARDS.

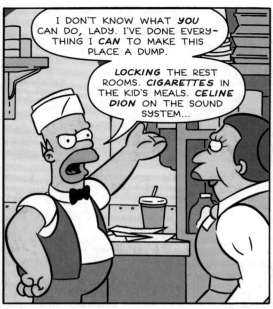

I DON'T KNOW WHAT *YOU* CAN DO, LADY. I'VE DONE EVERYTHING I *CAN* TO MAKE THIS PLACE A DUMP.

LOCKING THE REST ROOMS. *CIGARETTES* IN THE KID'S MEALS. *CELINE DION* ON THE SOUND SYSTEM...

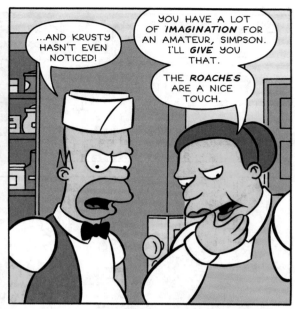

...AND KRUSTY HASN'T EVEN NOTICED!

YOU HAVE A LOT OF *IMAGINATION* FOR AN AMATEUR, SIMPSON. I'LL *GIVE* YOU THAT.

THE *ROACHES* ARE A NICE TOUCH.

I NAMED *THAT* ONE "CRAWLY."

BUT THERE'S SO MUCH *MORE* YOU COULD DO.

AND, AS SOMEONE WHO INCREASED THE *BAG* LUNCH-TO-*BOUGHT* LUNCH RATIO TO AN 80-20 SPLIT...

...I'M YOUR *MAN.*

BUT HOW WILL WE *DO* IT? *HOW?*

TWO LITTLE WORDS.

MILITARY.

SURPLUS.

UM... GREAT.

BUT CAN YOU *LOSE* THE CREEPY FLASHLIGHT?

NO.

OH-KAY.

SOON...

MILITARY ANTIQUES

DON'T GET MUCH *CALL* FOR THIS STUFF...

...ESPECIALLY IN THESE QUANTITIES.

WELL, I *LOST* MY PENTAGON CONTACTS.

TELL ME ABOUT IT. YOU GOTTA GO TO EASTERN EUROPE FOR *DECENT* FRAG GRENADES THESE DAYS.

BUT I *SHOULD* BE ABLE TO HOOK YOU UP.

ANYHOO, I GOT YOUR CASES OF G.I. TUNA, BULLY BEEF, AND GIZZARD LOAF--

BULLY BEEF

BULLY BEEF

EEF

HEY, *SKINNER*. YOU GONNA *BUY* SOMETHING? THIS AIN'T A *COSTUME* PARADE.

SORRY. I GOT *LOST* IN THE MOMENT.

DAD, I THINK THIS MEAT'S GONE *BAD*.

IT SMELLS LIKE OUR *SOFA*. AND THE *LID* IS RUSTY.

AND ISN'T THERE A *LAW* AGAINST CHILD LABOR?

JUST EMPTY THE CANS IN THE GRINDER AND *NONE* OF YOUR SASS.

YEAH, IT SMELLS LIKE *SASS*, TOO.

AND NOT ANOTHER *WORD* ABOUT CHILD LABOR LAWS, BOY.

C'MON, THOSE FRIES AREN'T GOING TO PULL *THEMSELVES* OUT, MAGGIE!

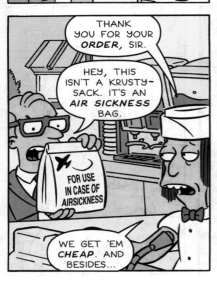

THANK YOU FOR YOUR *ORDER*, SIR.

HEY, THIS ISN'T A KRUSTY-SACK. IT'S AN *AIR SICKNESS* BAG.

FOR USE IN CASE OF AIRSICKNESS

WE GET 'EM *CHEAP*. AND BESIDES...

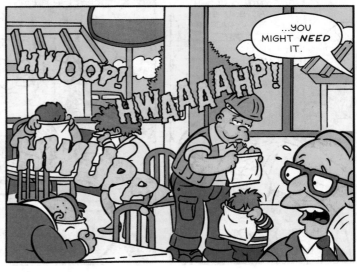

...YOU MIGHT *NEED* IT.

HWOOP!

HWAAAAHP!

HWUPP!

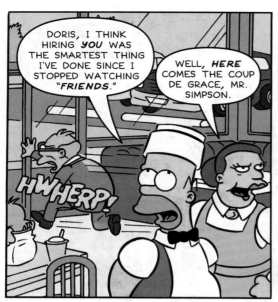

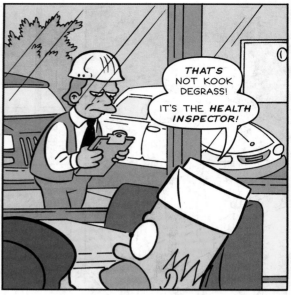

LATER, AT KRUSTYLU STUDIOS...

YOU GUYS, AGAIN? WITH THE NUMBERS AND ALL THAT GESCHEFT, YOU MAKE ME FARBLONDGET!

MR KRUSTY...

...YOU CAN SIT THERE AND **MAKE UP** WORDS OR LISTEN TO THESE PROJECTIONS.

THERE'S A **PROBLEM** WITH STORE #987976.

SO, **ONE** JOINT IS FALLING BEHIND.

IT'S **MORE** THAN THAT. THE PERFORMANCE OF #987976 IS CREATING A NEGATIVE SAME-STORE RECIDIVISM FOR THE ENTIRE AREA.

WE FORWARD LOOK A FREEFALL PROFIT TERMINIZING WITH SHIFTS TO THE MINUS COLUMN IN GEOMETRICAL PROGRESSION.

WHAT'S SO **BAD** ABOUT WHAT THE GUY WHO RUNS STORE #99-WHATSIS DID?

IN ENGLISH?

HE HOCKED A LOOGIE IN THE PUNCHBOWL, KRUSTY!

AND SOMEBODY'S GONNA HAVE TO LADLE IT OUT!

OW!

ALL RIGHT! **ALL RIGHT!**

IT'S TIME FOR **OPERATION LOOGIE LADLE!**

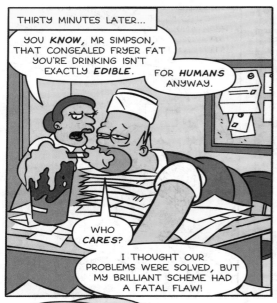

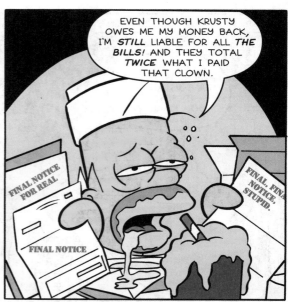

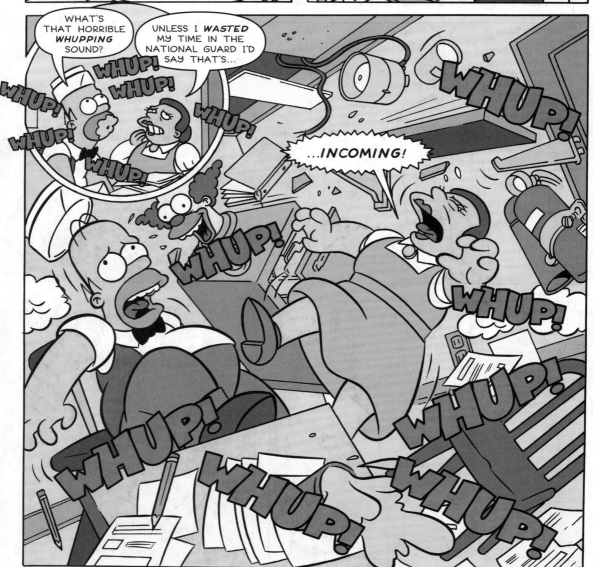

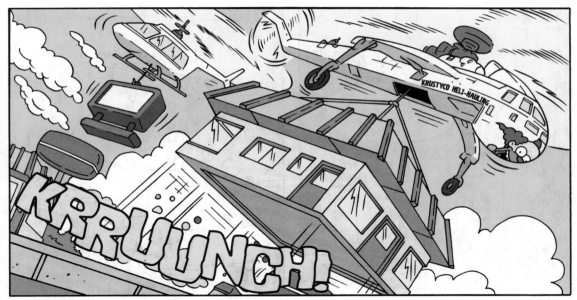

THE NEXT AFTERNOON...

WHERE'S HOMER?

YOUR FATHER'S OUT GETTING A *SECOND JOB* TO PAY THE CREDITORS.

WELL, AT LEAST WE CAN ALL GET BACK TO EATING HEALTHY.

AND I'LL HAVE TO GO BACK TO *PAYING* TO GET MY DAILY PERCENTAGE OF TRIGLYCERIDES.

THAT'S YOUR FATHER'S CAR I HEAR, KIDS.

LET'S ALL MEET HIM AT THE FRONT DOOR AND SHOW OUR SUPPORT.

SURE.

WHY NOT THROW HIM A BONE?

HELLO, HONEY! HOW WAS THE JOB HUNT?

OKAY, I GUESS.

NOW, DOES ANYONE HERE HAVE "PROBLEM SKIN?"

THE END

60

HOTFOOT IN THE PARK

IAN **BOOTHBY** STORY PHIL **ORTIZ** PENCILS MIKE **DECARLO** INKS ART **VILLANUEVA** COLORS KAREN **BATES** LETTERS BILL **MORRISON** EDITOR

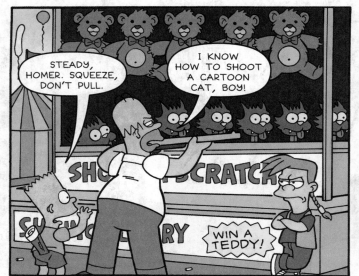

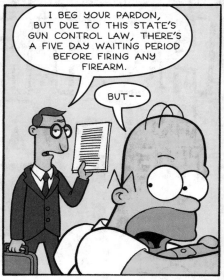

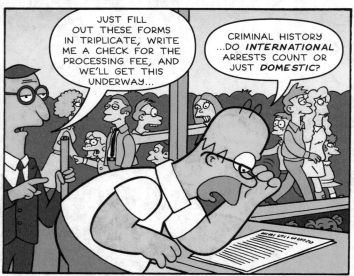

LATER...

ALL RIGHT! BART SIMPSON SCORES AGAIN! WHY ISN'T THIS AN OLYMPIC SPORT?

WHAT CAN I GET FOR ALL THESE?

HERE YOU GO!

WHAT? I SPENT TWENTY DOLLARS, AND ALL I GET IS A FIVE CENT WHISTLE IN THE SHAPE OF A WOMAN'S HEAD?

NOT JUST ANY WOMAN. THAT'S ERIN BROCKOVICH, AMERICA'S MOST BELOVED WHISTLE BLOWER!

WHAT A RIP OFF!

YOU'RE DOING IT ALL WRONG, SIMPSON. IT'S ALL IN THE WRIST. WATCH!

SMACK! THE BALL

SEE? ALL IN THE WRIST!

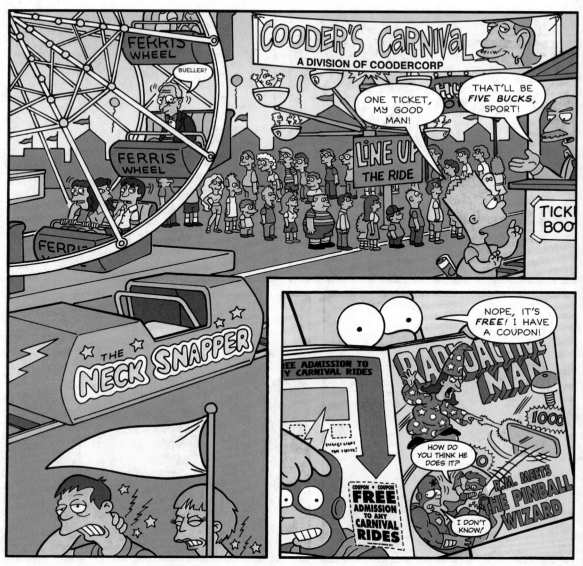

COODER'S CARNIVAL
A DIVISION OF COODERCORP

FERRIS WHEEL

BUELLER?

FERRIS WHEEL

FERRIS WHEEL

LINE UP THE RIDE

ONE TICKET, MY GOOD MAN!

THAT'LL BE *FIVE BUCKS*, SPORT!

TICKET BOOTH

★ THE ★ **NECK SNAPPER**

NOPE, IT'S *FREE!* I HAVE A COUPON!

FREE ADMISSION TO ANY CARNIVAL RIDES

COUPON • COUPON
FREE ADMISSION TO ANY CARNIVAL RIDES

RADIOACTIVE MAN
1000

HOW DO YOU THINK HE DOES IT?

I DON'T KNOW!

R.M. MEETS THE PINBALL WIZARD

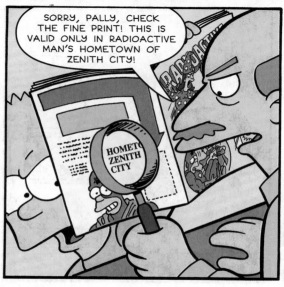

SORRY, PALLY, CHECK THE FINE PRINT! THIS IS VALID ONLY IN RADIOACTIVE MAN'S HOMETOWN OF ZENITH CITY!

HOMETOWN ZENITH CITY

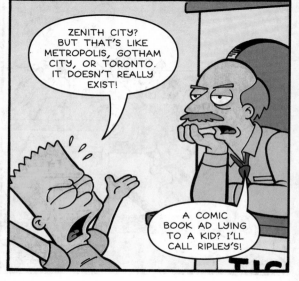

ZENITH CITY? BUT THAT'S LIKE METROPOLIS, GOTHAM CITY, OR TORONTO. IT DOESN'T REALLY EXIST!

A COMIC BOOK AD LYING TO A KID? I'LL CALL RIPLEY'S!

SO, LITTLE LADY, HOW MANY JELLY BEANS DO YOU THINK ARE IN THIS HERE JAR?

LET'S SEE, IT'S A STANDARD 40 OUNCE MASON PICKLING JAR SO TAKING INTO ACCOUNT THE HEIGHT AND DIAMETER...

THREE HUNDRED SIXTY FOUR.

UH... YEAH, THAT'S RIGHT!

HOT DOGS

YOU GOT LUCKY!

NO, I'VE JUST BEEN GETTING A LITTLE EXTRA TUTORING AFTER SCHOOL FROM *THE MATHEMAGICIAN*.

AND NOW FOR A TRICK I CALL "THE DISAPPEARING REMAINDER." PICK A FLASH CARD, ANY FLASH CARD!

251 X 119
5) 25,175
16² ÷ 118

MAYBE LATER.

POP A BALLOON! for 25¢

KNOC

OKAY, DOUBLE OR NOTHING! HOW MANY PICKLED EGGS?

HMMM...

ONE HUNDRED SEVEN EGGS!

HMM...

NINE HUNDRED EIGHTY SEVEN PEANUTS!

GRRR...

EIGHTY-TWO PIG'S FEET! EEEEW!

HEY, WHAT THE--? I WAS JUST WALKING BY!

GRA[N] PRIZ[E]

2N[D] PR[IZE]

WELL, IF YOU'RE OUT OF DOLLS, I'LL BE GETTING THESE OVER TO THE TOY DONATION BIN AT THE SPRINGFIELD ORPHANAGE.

NO, WAIT! I AIN'T NEVER LOST TO A RUBE BEFORE!

GIVE ME ONE LAST CHANCE TO DEFEND MY CARNEY HONOR. IF YOU WIN, I'LL...I'LL GIVE YOU *THE FAIR* ITSELF!

REALLY?

ALL YOU HAVE TO DO IS GUESS HOW MANY JARS ARE IN THE *MEGA JAR!* AND HOW MANY OBJECTS ARE IN *THEM!*

¡GASP!¿

MAY I BORROW YOUR ABACUS?

BUT OF COURSE. TO BE HONEST, I DON'T REALLY EVEN KNOW WHY I CARRY IT WITH ME. I SHOULD JUST BREAK DOWN AND GET A CALCULATOR!

CLICK! CLICK! CLACK!

CLICK! CLICK! CLACK!

THERE ARE 986 JARS AND THE TOTAL CONTENTS OF THE OBJECT IN THE JARS ARE...

...TWO HUNDRED THOUSAND ONE HUNDRED FIFTY EIGHT!

=SIGH= THAT'S RIGHT.

HOORAY!

THE FAIR'S *YOURS*, LITTLE LADY.

I GUESS THERE'S NOTHING LEFT FOR ME TO DO BUT GO BACK TO MY OLD JOB AS A HILLBILLY DENTIST.

DOC, YA GOTTA FIX MY TEETH. THEY ALL DONE GREW BACK AGAIN!

JUST HOLD STILL AND TRY NOT TO SWALLOW THE SHARDS!

INEVITABLY...

MY SHOP! MY FORTRESS OF SOLITUDE! MY *SANCTUM SANCTORUM!*

AND *YOU!* YOU DID *NOTHING!*

YEAH, SORRY. WE WERE HIRED FOR OUR LOOKS!

WE'RE NO GOOD WITH FIRE, BUT, MAN, CAN WE SELL CALENDARS!

NO ONE EVEN KNOWS HOW TO DRIVE THE TRUCK. WE HAD TO PUSH IT ALL THE WAY HERE!

MARCH

I'M REALLY SORRY ALL THIS HAPPENED.

NOT AS SORRY AS YOU'RE GOING TO BE WHEN I SUE YOU FOR EVERY PENNY IN YOUR PIGGY BANK!

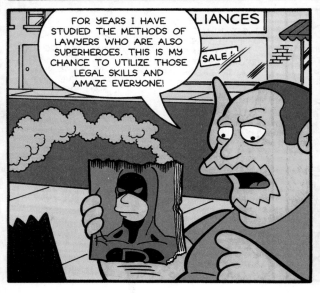

FOR YEARS I HAVE STUDIED THE METHODS OF LAWYERS WHO ARE ALSO SUPERHEROES. THIS IS MY CHANCE TO UTILIZE THOSE LEGAL SKILLS AND AMAZE EVERYONE!

LIANCES

SALE!

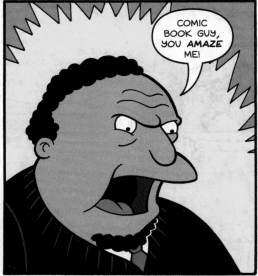

COMIC BOOK GUY, YOU *AMAZE* ME!

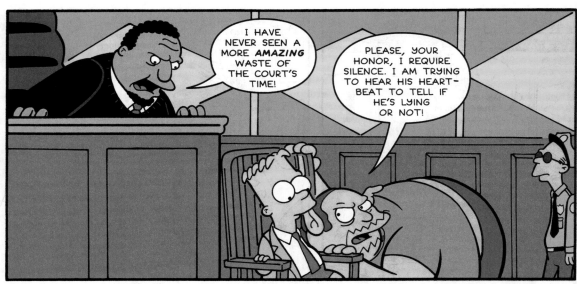

I HAVE NEVER SEEN A MORE *AMAZING* WASTE OF THE COURT'S TIME!

PLEASE, YOUR HONOR, I REQUIRE SILENCE. I AM TRYING TO HEAR HIS HEARTBEAT TO TELL IF HE'S LYING OR NOT!

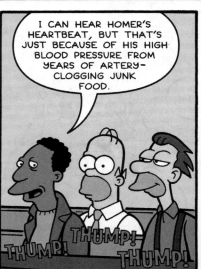

I CAN HEAR HOMER'S HEARTBEAT, BUT THAT'S JUST BECAUSE OF HIS HIGH BLOOD PRESSURE FROM YEARS OF ARTERY-CLOGGING JUNK FOOD.

THUMP! THUMP! THUMP!

WELL, I'LL SHOW YOU! I'M GOING TO GO ON A DIET AND START EXERCISING TOMORROW!

THUMP! THUMP! KA-THUMP!

KA-THUMP! KA-THUMP!

LIAR.

THE COURT FINDS IN FAVOR OF BART SIMPSON AND ORDERS THE BAILIFF TO MAKE COMIC BOOK GUY'S EARS NORMAL AGAIN! THEY REALLY CREEP ME OUT!

BANG!

NOW WHERE WILL I GO? WHAT WILL I DO? I FEEL AS USELESS AS FOX MULDER'S REPLACEMENT IN THE LAST SEASON OF "THE X-FILES."

WELL, I *DO* FEEL BAD THAT THIS HAPPENED. LOOK, I'VE GOT AN IDEA...

WILL LITIGATE FOR FOOD

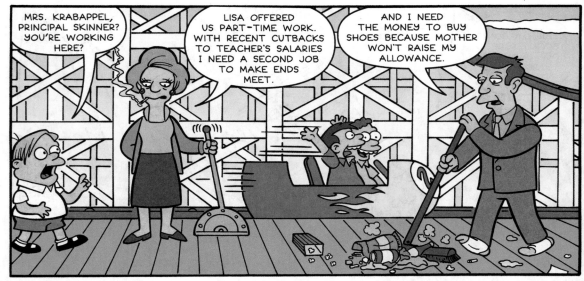

MRS. KRABAPPEL, PRINCIPAL SKINNER? YOU'RE WORKING HERE?

LISA OFFERED US PART-TIME WORK. WITH RECENT CUTBACKS TO TEACHER'S SALARIES I NEED A SECOND JOB TO MAKE ENDS MEET.

AND I NEED THE MONEY TO BUY SHOES BECAUSE MOTHER WON'T RAISE MY ALLOWANCE.

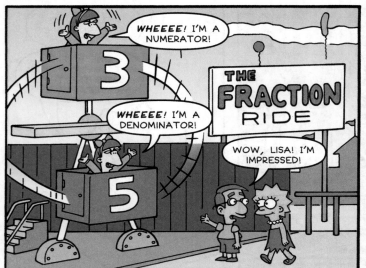

WHEEEE! I'M A NUMERATOR!

3

THE **FRACTION** RIDE

WHEEEE! I'M A DENOMINATOR!

5

WOW, LISA! I'M IMPRESSED!

IS THERE A *"TUNNEL OF LOVE"*?

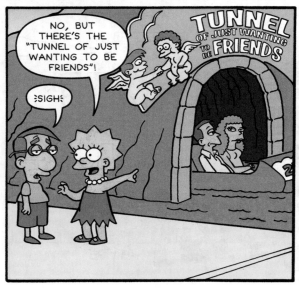

NO, BUT THERE'S THE "TUNNEL OF JUST WANTING TO BE FRIENDS"!

TUNNEL OF JUST WANTING TO BE FRIENDS

⸨SIGH⸩

HEY! *I* WAS TOLD WE HAVE TO PASS A POP QUIZ TO RIDE THE ROLLER-COASTER.

IT'S TRUE! AT LISALAND THE RIDES YOU *EARN* ARE BECAUSE YOU *LEARN!*

YOUR GRADE MUST BE THIS HIGH TO RIDE ↓

A
B
C
D
F

ELSEWHERE...

I'M JUST SAYING. THIS TOWN NEEDS A *REAL* FIRE DEPARTMENT. IT'S A *SAFETY* ISSUE!

LOOK, ARE YOU GONNA TALK ALL NIGHT OR PLAY "FLAMING AXE DARTS"?

Y'KNOW, HE'S RIGHT. THIS PLACE HERE'S BURNED TO THE GROUND FIVE TIMES SINCE I TOOK IT OVER. AND ONLY THREE OF THEM FIRES WAS INSURANCE SCAMS!

YEAH, BUT WHAT ARE YA GONNA DO?

I GOT AN IDEA! WOW, AND THEY SAID MY ALCOHOL-DAMAGED BRAIN CELLS WOULDN'T *EVER* GROW BACK!

MAYOR QUIMBY?

WHAT?! IS MY WIFE HERE?

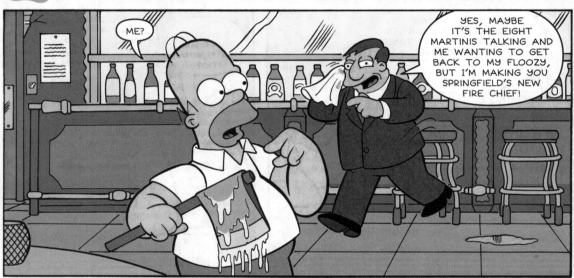

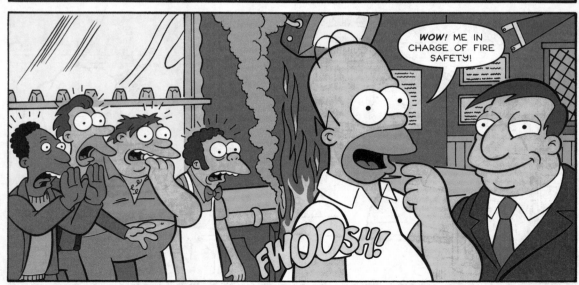

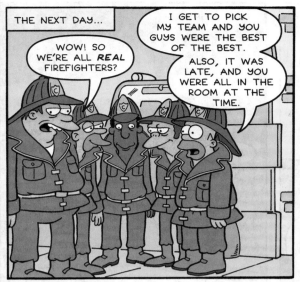

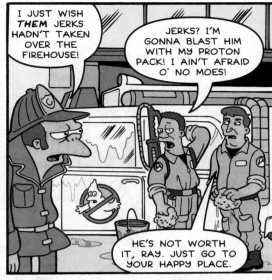

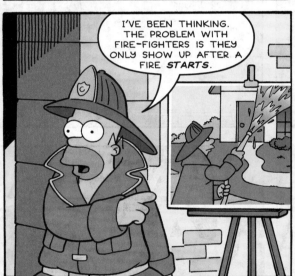

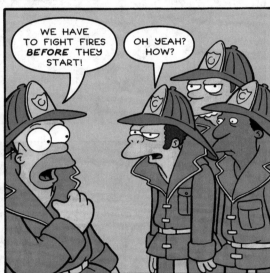

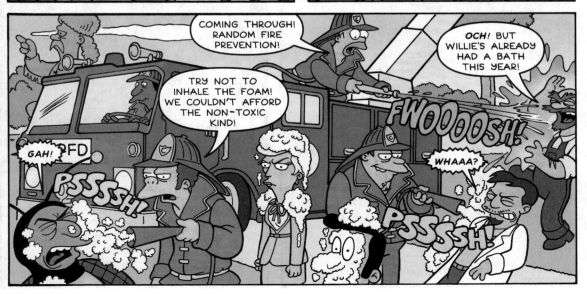

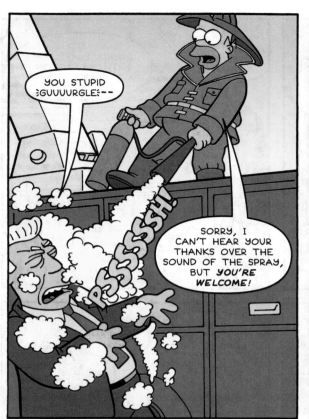

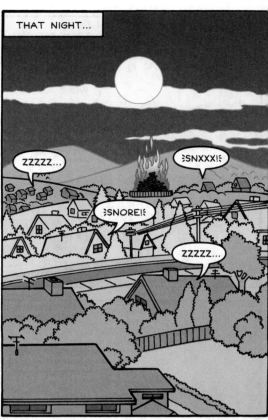

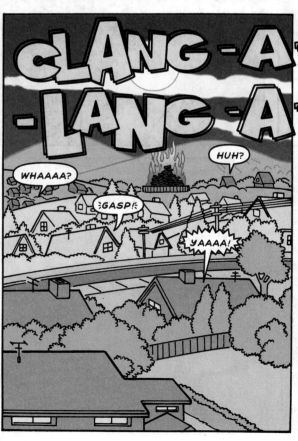

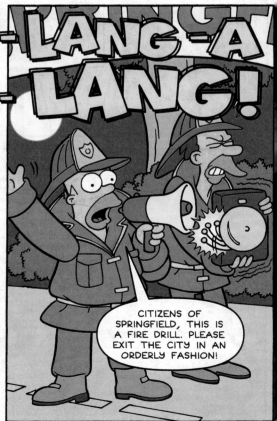

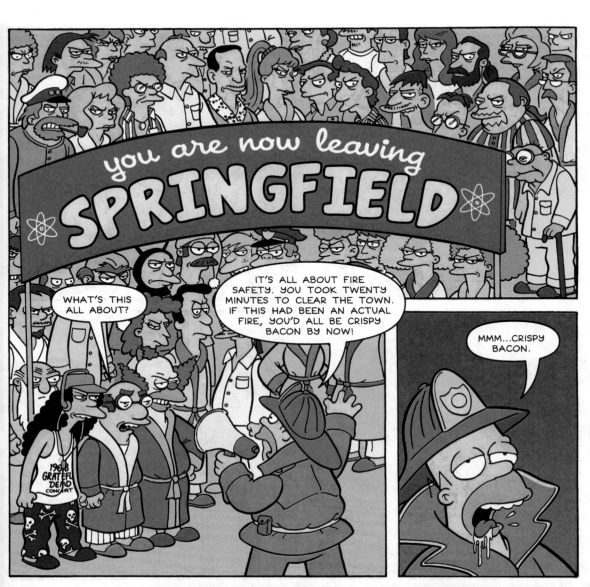

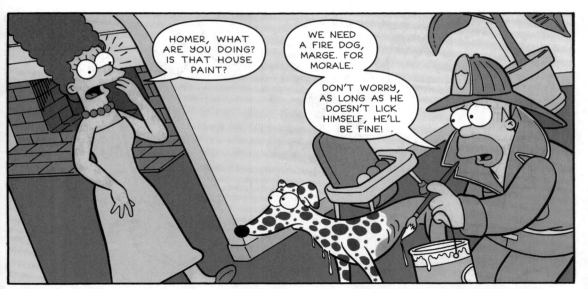

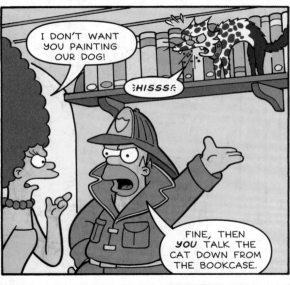

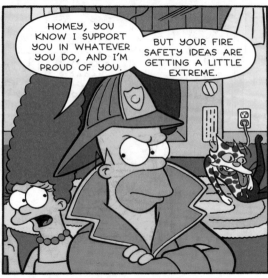

82

83

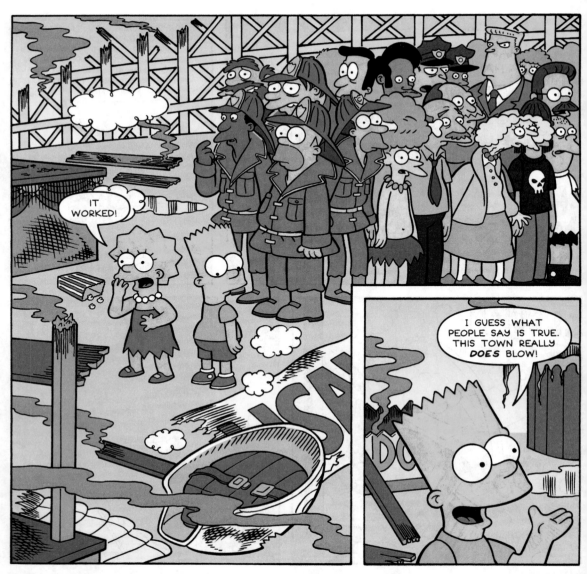

IT WORKED!

I GUESS WHAT PEOPLE SAY IS TRUE. THIS TOWN REALLY *DOES* BLOW!

RALPHIE! YOU SAVED EVERYONE! AND YOUR PANTS STAYED BONE DRY DOING IT! I'M SO PROUD OF YOU!

YOU'VE EARNED A TREAT. WHAT SAY I TAKE YOU TO THE STATION AND LET YOU SMACK THE PERPS AROUND WITH A PHONE BOOK?

I'D RATHER STAY HERE AND PLAY. BUT I'M NOT SMART ENOUGH TO GO ON THE RIDES.

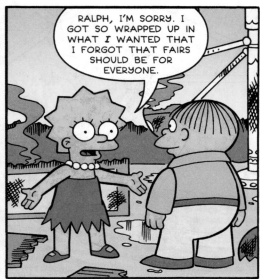

RALPH, I'M SORRY. I GOT SO WRAPPED UP IN WHAT *I* WANTED THAT I FORGOT THAT FAIRS SHOULD BE FOR EVERYONE.

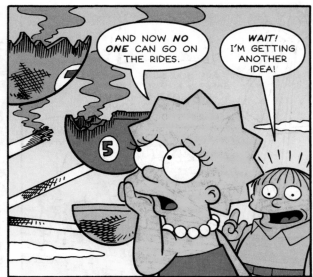

AND NOW *NO ONE* CAN GO ON THE RIDES.

WAIT! I'M GETTING ANOTHER IDEA!

WELL, WHAT *IS* IT?

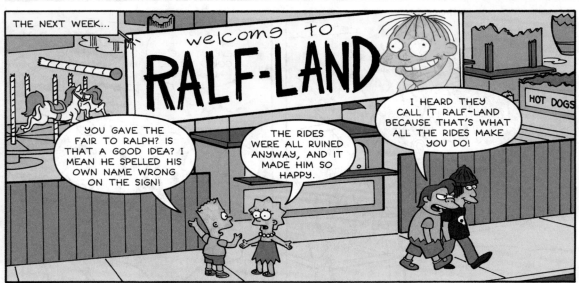

THE NEXT WEEK...

welcome to RALF-LAND

YOU GAVE THE FAIR TO RALPH? IS THAT A GOOD IDEA? I MEAN HE SPELLED HIS OWN NAME WRONG ON THE SIGN!

THE RIDES WERE ALL RUINED ANYWAY, AND IT MADE HIM SO HAPPY.

I HEARD THEY CALL IT RALF-LAND BECAUSE THAT'S WHAT ALL THE RIDES MAKE YOU DO!

HOT DOGS

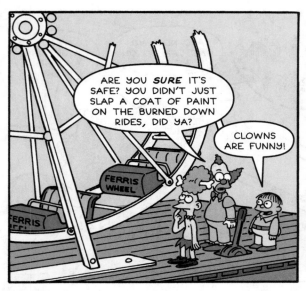

86

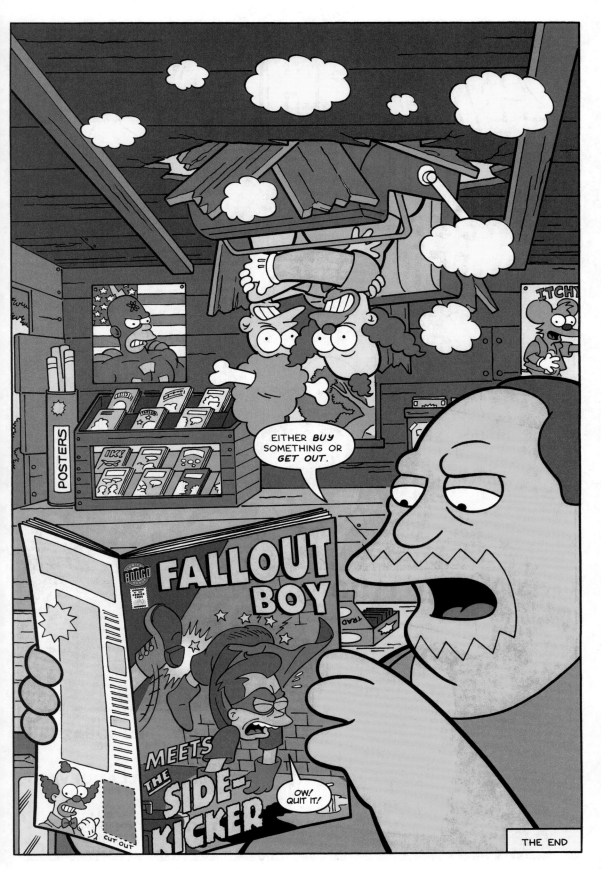

MATT GROENING
PRESENTS

24/7TH HEAVEN

LEFT HANDERS RULE!

I...I'M NOT SURE ABOUT THIS. I KNOW BUSINESS IS BAD, BUT I NEVER THOUGHT I'D BE SIGNING A CONTRACT WITH ≤GULP≥ *YOU!*

JUST SIGN ON THE DOTTED LINE!

Contract

IAN BOOTHBY
SCRIPT

LUIS ESCOBAR
PENCILS

PATRICK OWSLEY
INKS

ART VILLANUEVA
COLORS

KAREN BATES
LETTERS

BILL MORRISON
EDITOR

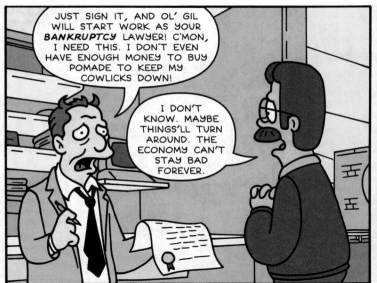

JUST SIGN IT, AND OL' GIL WILL START WORK AS YOUR *BANKRUPTCY* LAWYER! C'MON, I NEED THIS. I DON'T EVEN HAVE ENOUGH MONEY TO BUY POMADE TO KEEP MY COWLICKS DOWN!

I DON'T KNOW. MAYBE THINGS'LL TURN AROUND. THE ECONOMY CAN'T STAY BAD FOREVER.

THE WOLF'S AT EVERYONE'S DOOR NOWADAYS.

SEE?

BOOTLEG RICKY'S ~~RECORDS~~ MP3s

DO YOU HAVE THE NEW WHITESNAKE DOWNLOAD?

IT'LL TAKE FIVE MINUTES. I ONLY GOT A *DIAL-UP* MAN.

FLAVOR ICE CREAM

VANILLA AND UNREFRIGERATED VANILLA.

BED, BATH, AND *Boudoir*

DO YOU HAVE ANY WITH LESS *HAIR* ON THEM?

ASK ABOUT OUR USED HOTEL SOAP

I CAN THROW IN A *RAZOR* FOR A *BUCK*.

YES, TIMES ARE HARD FOR EVERYONE, WITH MERCHANTS HAVING TO FIND NEW SOURCES OF INCOME...

GREETINGS, GENTLE ELDERS, AND BEHOLD THE FUTURE...

SPRINGFIELD RETIREMENT CASTLE

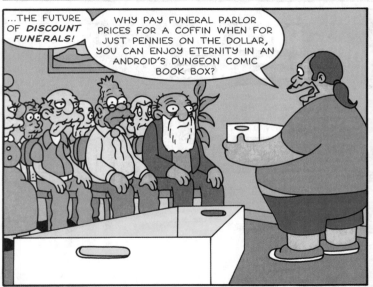

...THE FUTURE OF *DISCOUNT FUNERALS!*

WHY PAY FUNERAL PARLOR PRICES FOR A COFFIN WHEN FOR JUST PENNIES ON THE DOLLAR, YOU CAN ENJOY ETERNITY IN AN ANDROID'S DUNGEON COMIC BOOK BOX?

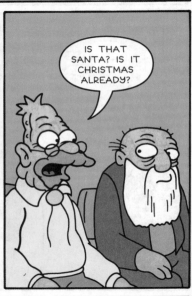

IS THAT SANTA? IS IT CHRISTMAS ALREADY?

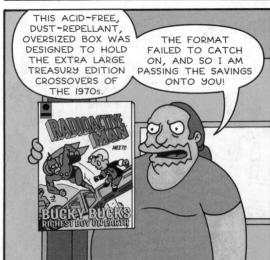

THIS ACID-FREE, DUST-REPELLANT, OVERSIZED BOX WAS DESIGNED TO HOLD THE EXTRA LARGE TREASURY EDITION CROSSOVERS OF THE 1970s.

THE FORMAT FAILED TO CATCH ON, AND SO I AM PASSING THE SAVINGS ONTO YOU!

RADIOACTIVE MAN MEETS

BUCKY BUCKS RICHEST BOY ON EARTH

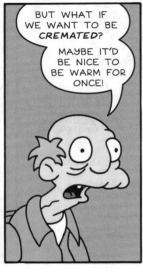

BUT WHAT IF WE WANT TO BE *CREMATED?*

MAYBE IT'D BE NICE TO BE WARM FOR ONCE!

THEN FORGET THE URN AND HAVE YOUR ASHES PRESERVED IN ONE OF OUR VERY AFFORDABLE *MYLAR COMIC BAGS!*

REMEMBER OUR MOTTO, "A PENNY IS *SAVED* WHEN YOU'RE NOT *URNED!*"

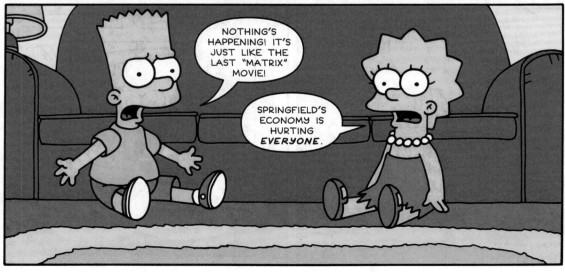

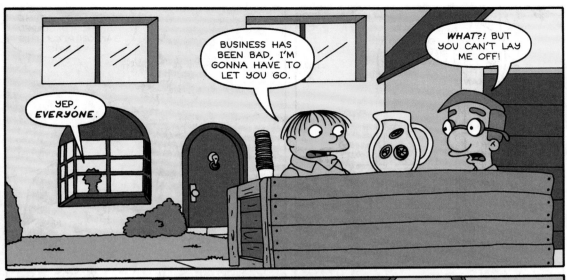

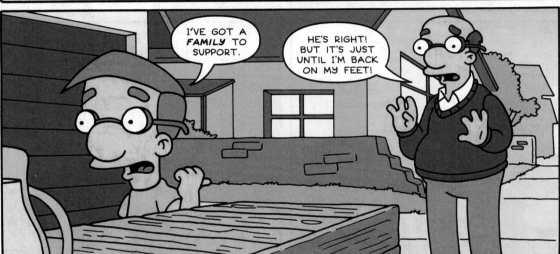

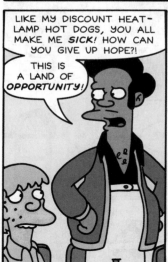

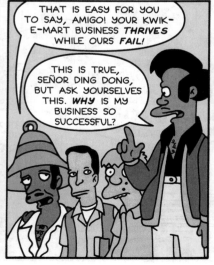

UM...WELL, YES, BUT MORE THAN THAT IS MY *COMMITMENT* TO MY CUSTOMERS!

I AM OPEN *TWENTY-FOUR* HOURS A DAY, *SEVEN* DAYS A WEEK!

YOUR NINE-TO-FIVE HOURS DON'T *CALCUTTA IT* IN TODAY'S TWENTY-FOUR HOUR WORLD!

BY CLOSING AT NIGHT YOU ARE MISSING OUT ON THREE *KEY IMPULSE BUYING* CUSTOMERS.

THE INSOMNIACS! MEN WHO HAVE HAD A FIGHT WITH THEIR WIVES AND BEEN KICKED OUT! AND *VAMPIRES!*

HE'S RIGHT! I DON'T *WANT* TO WEAR THIS *TUXEDO* EVERY DAY, BUT THE *SWEATER VEST* STORE IS CLOSED AT NIGHT!

ALL IN FAVOR OF MAKING ALL SPRINGFIELD BUSINESSES OPEN TWENTY-FOUR HOURS, SAY "AYE!"

"AYE!"

SPRINGFIELD TOWN HALL

TONIGHT-SPRINGFIELD MERCHANT'S ASSOCIATION
TOMORROW-HUMAN CANNONBALL CONVENTION

95

THE NEXT NIGHT...

WHTRRR!

HONK!

BEEP!

WOW, LOOK AT THE CITY! IT'S SO BRIGHT AND LOUD! IT'S HARD TO BELIEVE IT'S 11 P.M.!

ALL THE LIGHT IS REALLY CONFUSING THE BIRDS

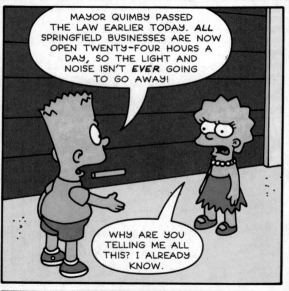

MAYOR QUIMBY PASSED THE LAW EARLIER TODAY. *ALL* SPRINGFIELD BUSINESSES ARE NOW OPEN TWENTY-FOUR HOURS A DAY, SO THE LIGHT AND NOISE ISN'T *EVER* GOING TO GO AWAY!

WHY ARE YOU TELLING ME ALL THIS? I ALREADY KNOW.

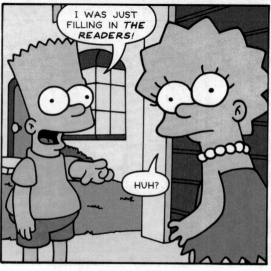

I WAS JUST FILLING IN *THE READERS!*

HUH?

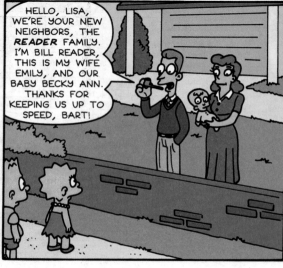

HELLO, LISA, WE'RE YOUR NEW NEIGHBORS, THE *READER* FAMILY. I'M BILL READER, THIS IS MY WIFE EMILY, AND OUR BABY BECKY ANN. THANKS FOR KEEPING US UP TO SPEED, BART!

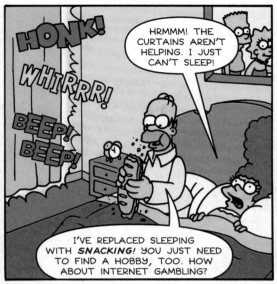

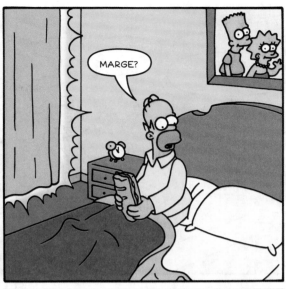

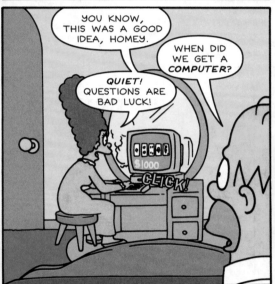

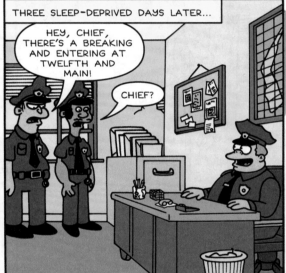

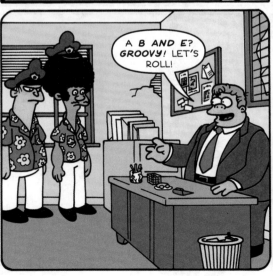

MEANWHILE...

OPENING CHEVRON 9 OF THE STARGATE!

UH-OH.

WHAT?

I HAVEN'T SLEPT IN SO LONG I'VE FORGOTTEN WHICH ONE OF US IS *PATTY* AND WHICH IS *SELMA*.

ME, TOO.

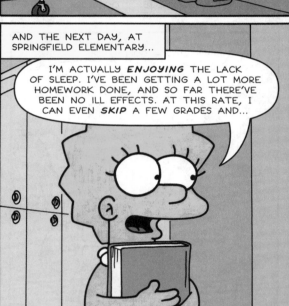

AND THE NEXT DAY, AT SPRINGFIELD ELEMENTARY...

I'M ACTUALLY *ENJOYING* THE LACK OF SLEEP. I'VE BEEN GETTING A LOT MORE HOMEWORK DONE, AND SO FAR THERE'VE BEEN NO ILL EFFECTS. AT THIS RATE, I CAN EVEN *SKIP* A FEW GRADES AND...

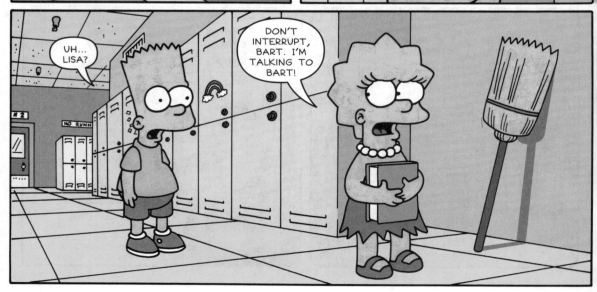

UH... LISA?

DON'T INTERRUPT, BART. I'M TALKING TO BART!

MEANWHILE...

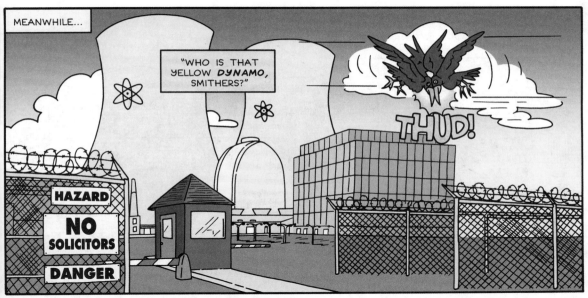

"WHO IS THAT YELLOW *DYNAMO*, SMITHERS?"

THUD!

HAZARD
NO SOLICITORS
DANGER

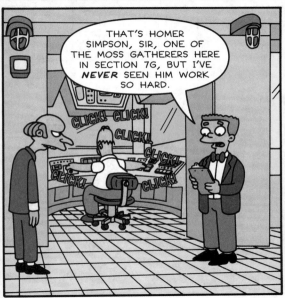

THAT'S HOMER SIMPSON, SIR, ONE OF THE MOSS GATHERERS HERE IN SECTION 7G, BUT I'VE *NEVER* SEEN HIM WORK SO HARD.

CLICK! CLICK! CLICK! CLICK! CLICK!

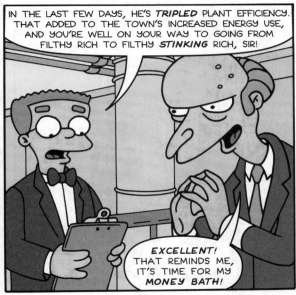

IN THE LAST FEW DAYS, HE'S *TRIPLED* PLANT EFFICIENCY. THAT ADDED TO THE TOWN'S INCREASED ENERGY USE, AND YOU'RE WELL ON YOUR WAY TO GOING FROM FILTHY RICH TO FILTHY *STINKING* RICH, SIR!

EXCELLENT! THAT REMINDS ME, IT'S TIME FOR MY *MONEY BATH!*

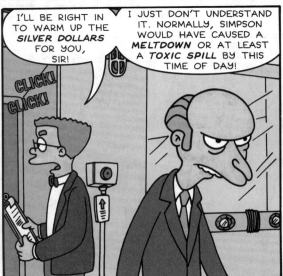

I'LL BE RIGHT IN TO WARM UP THE *SILVER DOLLARS* FOR YOU, SIR!

I JUST DON'T UNDERSTAND IT. NORMALLY, SIMPSON WOULD HAVE CAUSED A *MELTDOWN* OR AT LEAST A *TOXIC SPILL* BY THIS TIME OF DAY!

CLICK! CLICK!

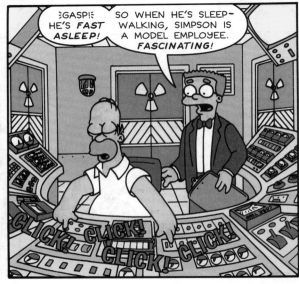

⸝GASP!⸝ HE'S *FAST ASLEEP!*

SO WHEN HE'S SLEEP-WALKING, SIMPSON IS A MODEL EMPLOYEE. *FASCINATING!*

CLICK! CLICK! CLICK! CLICK!

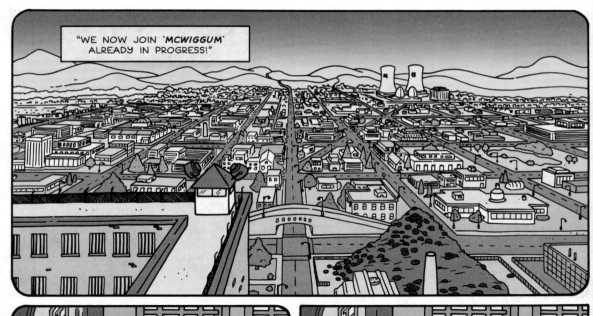

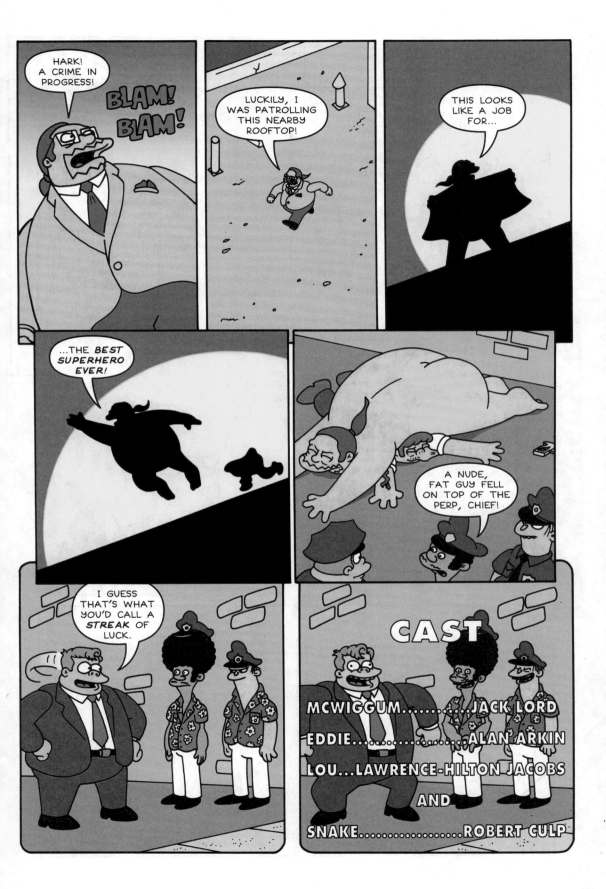

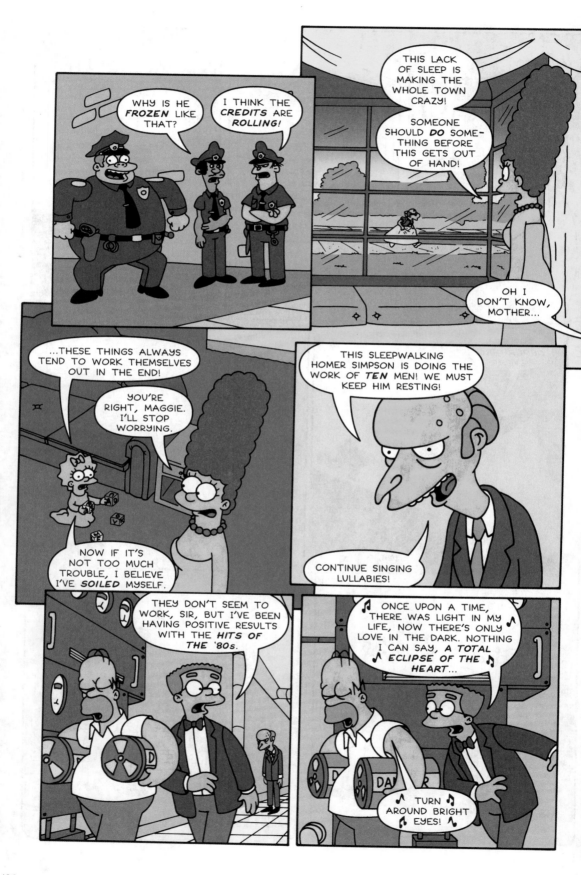

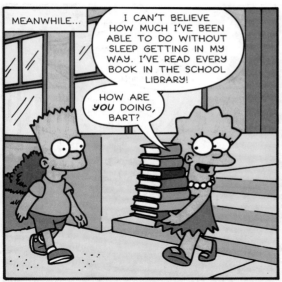

103

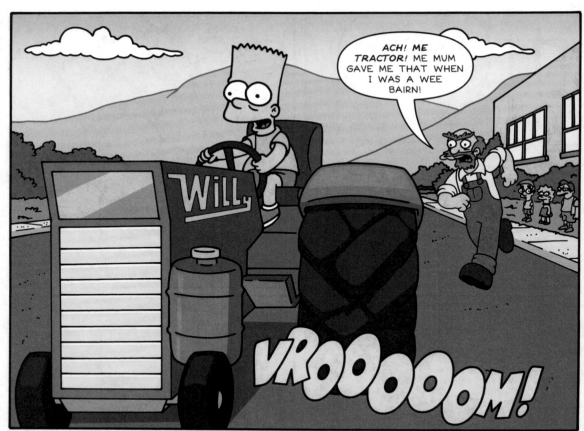
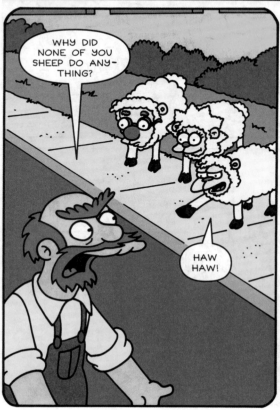

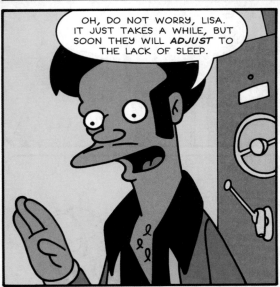

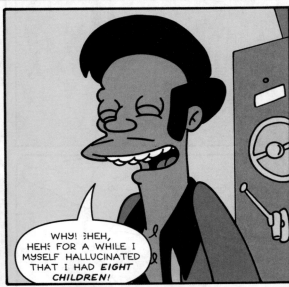

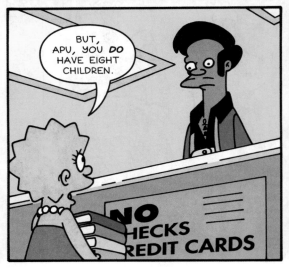

MEANWHILE...

YES! WORK, MY NOCTURNAL SUPERMAN, *WORK*! WHY I DO BELIEVE I'LL BE ABLE TO LAY OFF HALF OF MY WORKFORCE AT THIS RATE!

YES, WELL DONE, SIR! IF YOU DON'T MIND ME ASKING, WHY AREN'T *YOU* HALLUCINATING LIKE THE REST OF THE TOWN?

I GAVE UP SLEEPING AFTER I WAS VISITED BY THREE GHOSTS ONE CHRISTMAS EVE AND WAS TRICKED INTO BUYING AN EMPLOYEE A GOOSE DINNER!

SLEEPING, BAH HUMBUG!

YOU WERE AHEAD OF YOUR TIME, SIR!

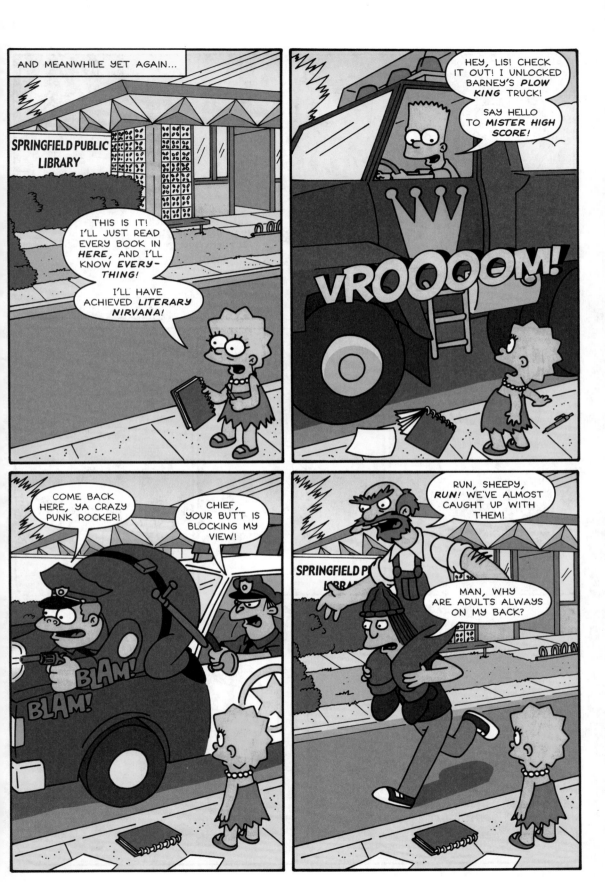

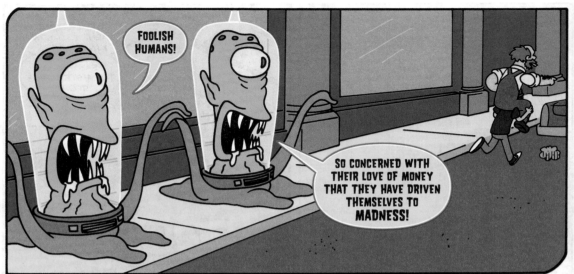

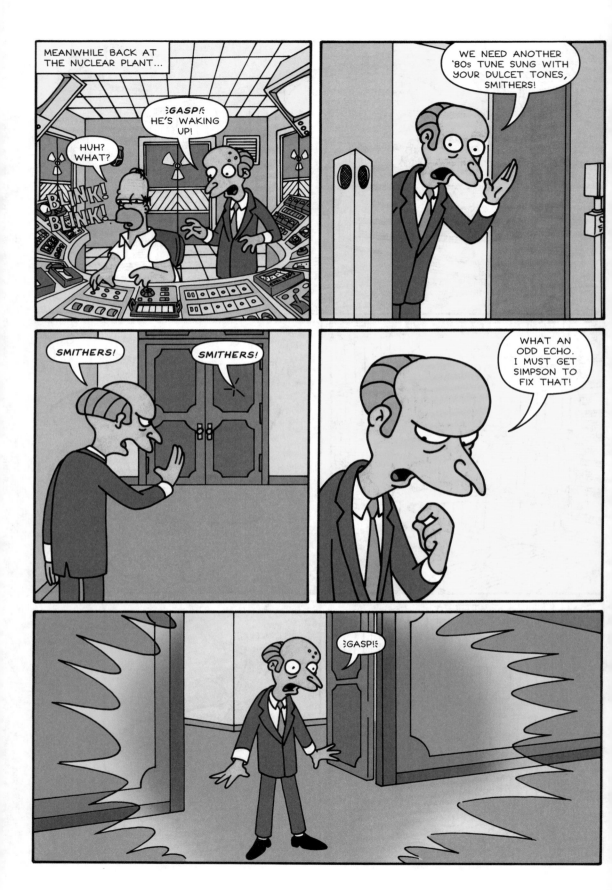

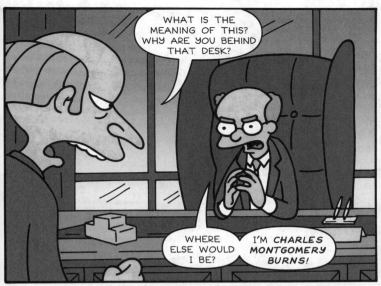

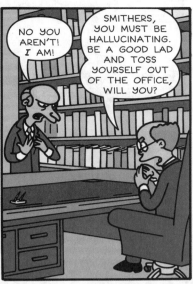

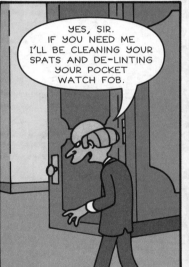

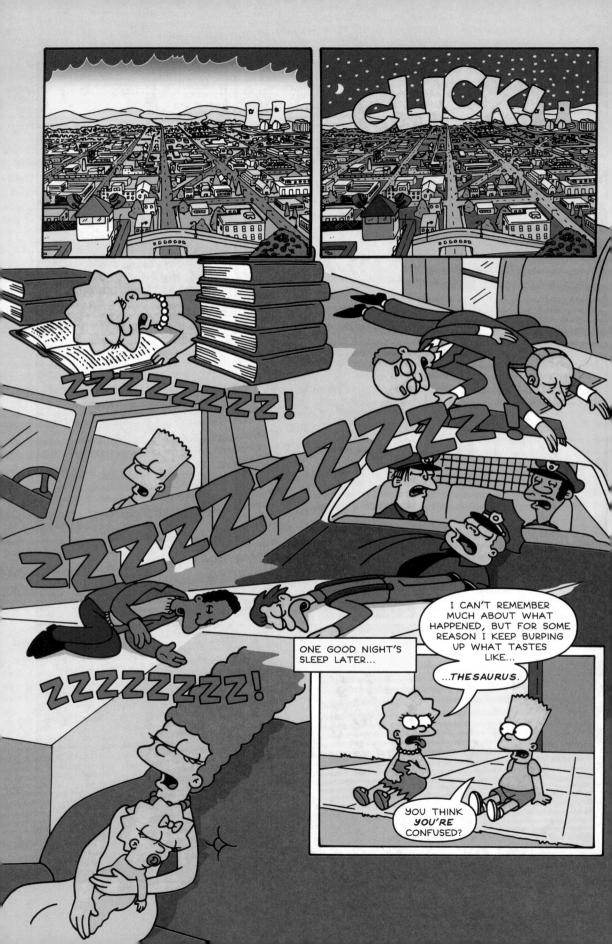

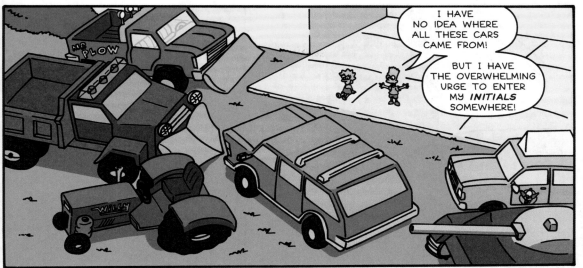

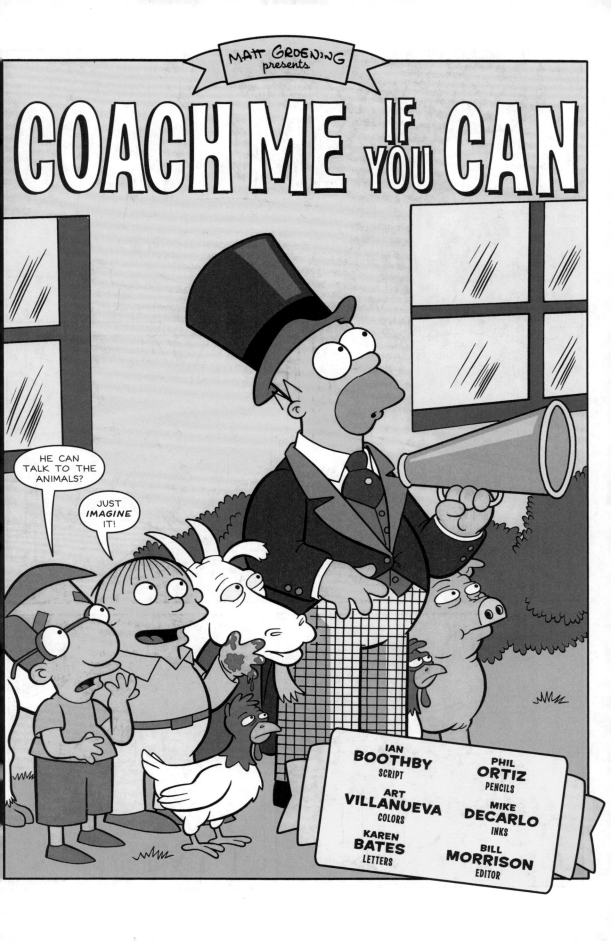

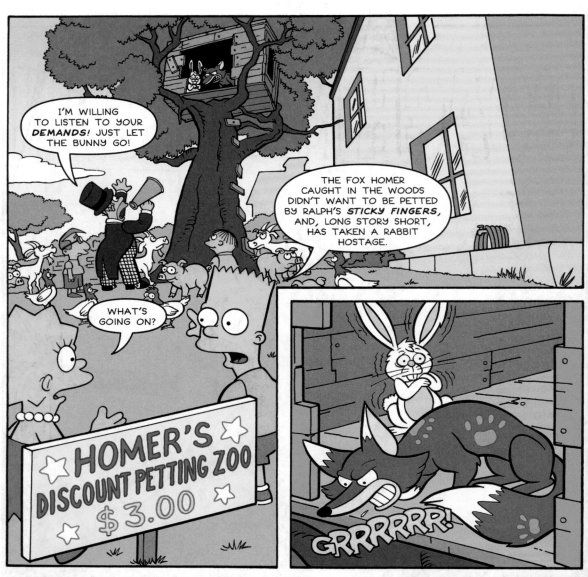

I'M WILLING TO LISTEN TO YOUR *DEMANDS!* JUST LET THE BUNNY GO!

THE FOX HOMER CAUGHT IN THE WOODS DIDN'T WANT TO BE PETTED BY RALPH'S *STICKY FINGERS*, AND, LONG STORY SHORT, HAS TAKEN A RABBIT HOSTAGE.

WHAT'S GOING ON?

HOMER'S DISCOUNT PETTING ZOO $3.00

GRRRRRR!

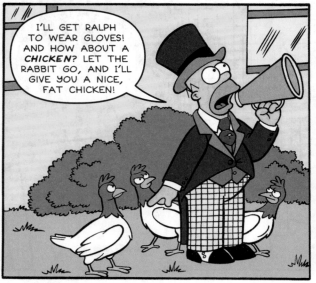

I'LL GET RALPH TO WEAR GLOVES! AND HOW ABOUT A *CHICKEN*? LET THE RABBIT GO, AND I'LL GIVE YOU A NICE, FAT CHICKEN!

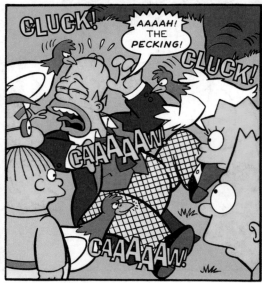

CLUCK!

AAAAH! THE *PECKING!*

CLUCK!

CAAAAAW!

CAAAAAW!

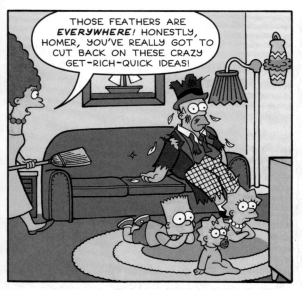

THOSE FEATHERS ARE *EVERYWHERE!* HONESTLY, HOMER, YOU'VE REALLY GOT TO CUT BACK ON THESE CRAZY GET-RICH-QUICK IDEAS!

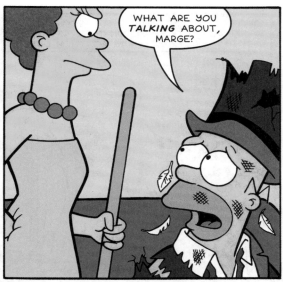

WHAT ARE YOU *TALKING* ABOUT, MARGE?

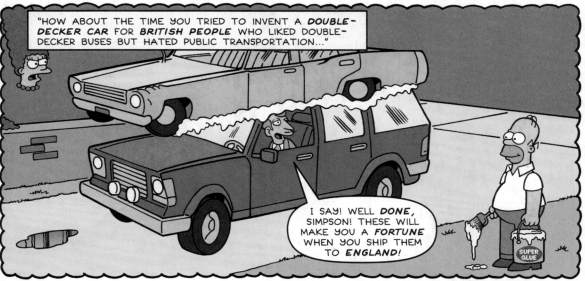

"HOW ABOUT THE TIME YOU TRIED TO INVENT A *DOUBLE-DECKER CAR* FOR *BRITISH PEOPLE* WHO LIKED DOUBLE-DECKER BUSES BUT HATED PUBLIC TRANSPORTATION..."

I SAY! WELL *DONE,* SIMPSON! THESE WILL MAKE YOU A *FORTUNE* WHEN YOU SHIP THEM TO *ENGLAND!*

SUPER GLUE

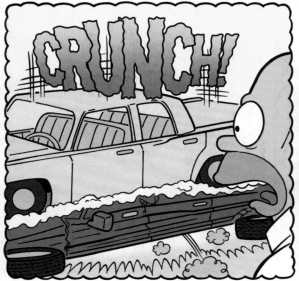

CRUNCH!

OH, AND UM... IT FITS COMPACTLY IN ANY GARAGE.

QUITE.

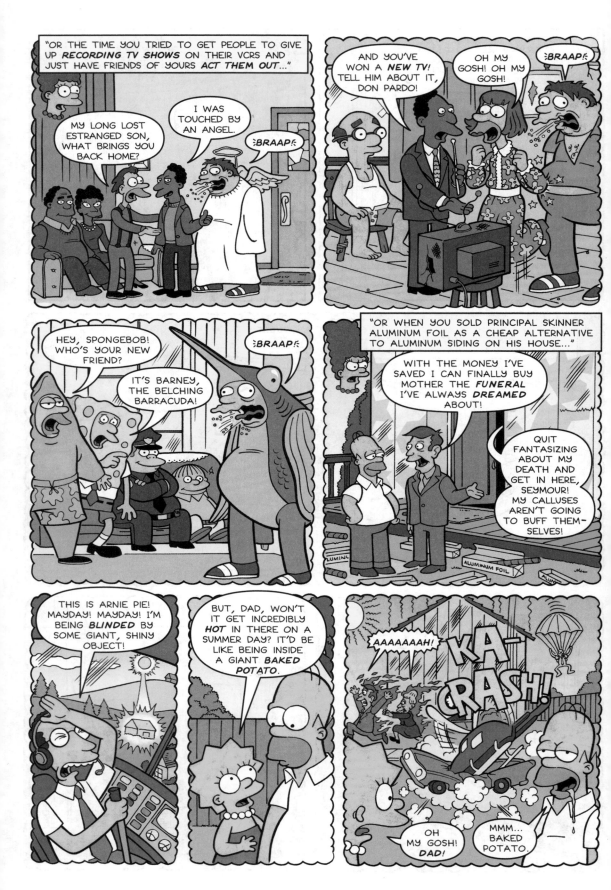

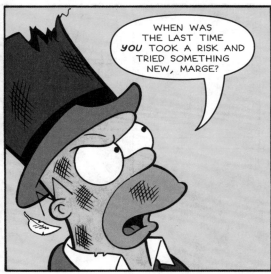

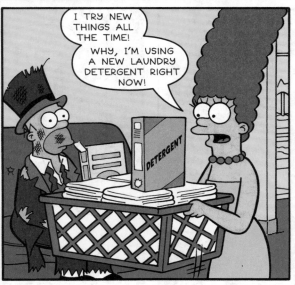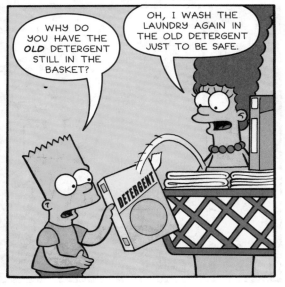

MOM, FOR ONCE DAD HAS A POINT. TAKE IT FROM SOMEONE WHO KNOWS, YOU'RE IN A RUT!

LOOK, YOU'VE WORN A PATH IN THE RUG FROM THE BEDROOM TO THE LAUNDRY ROOM...

LAUNDRY ROOM? I THOUGHT THAT WAS A CLOSET!

FROM THE LAUNDRY ROOM TO THE KITCHEN...

AND THE KITCHEN TO MAGGIE'S ROOM THEN BACK TO YOUR BEDROOM! THAT'S THE ROADMAP OF YOUR LIFE, MOM.

HRMMM...

THAT NIGHT...

FUNNY STORY. THE THING IS, BEFORE I GOT THE PART ON MEXICAN TELEVISION I DIDN'T A SPEAK A WORD OF SPANISH. I'M ACTUALLY *BELGIAN!*

WHY AREN'T YOU IN BED BY NOW?

I'M TOO *DEPRESSED* TO SLEEP.

WE'LL RETURN TO *A & E'S "BEE-OGRAPHY"* AFTER THESE MESSAGES.

YOU KNOW WHAT MIGHT CHEER YOU UP? MAKING ME A SANDWICH!

IS YOUR LIFE GOING NOWHERE?

YES!

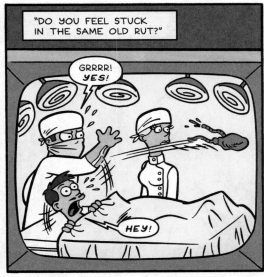

"DO YOU FEEL STUCK IN THE SAME OLD RUT?"

GRRRR! *YES!*

HEY!

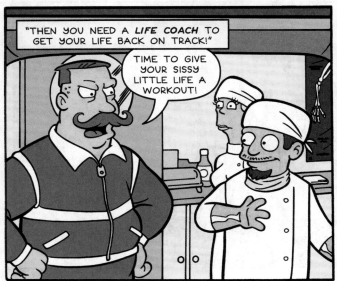

"THEN YOU NEED A *LIFE COACH* TO GET YOUR LIFE BACK ON TRACK!"

TIME TO GIVE YOUR SISSY LITTLE LIFE A WORKOUT!

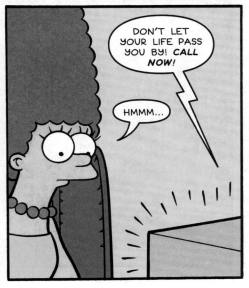

DON'T LET YOUR LIFE PASS YOU BY! *CALL NOW!*

HMMM...

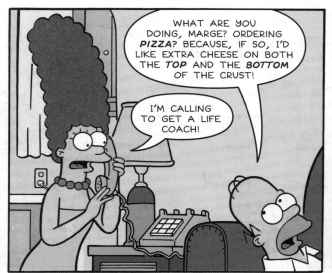

WHAT ARE YOU DOING, MARGE? ORDERING *PIZZA*? BECAUSE, IF SO, I'D LIKE EXTRA CHEESE ON BOTH THE *TOP* AND THE *BOTTOM* OF THE CRUST!

I'M CALLING TO GET A LIFE COACH!

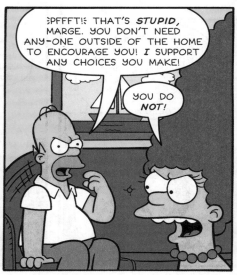

⊱PFFFT!⊰ THAT'S *STUPID*, MARGE. YOU DON'T NEED ANY-ONE OUTSIDE OF THE HOME TO ENCOURAGE YOU! *I* SUPPORT ANY CHOICES YOU MAKE!

YOU DO *NOT*!

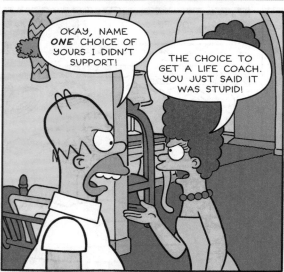

OKAY, NAME *ONE* CHOICE OF YOURS I DIDN'T SUPPORT!

THE CHOICE TO GET A LIFE COACH. YOU JUST SAID IT WAS *STUPID*!

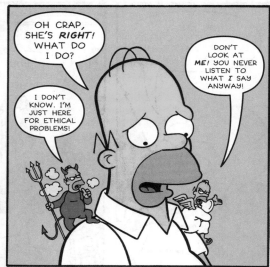

OH CRAP, SHE'S *RIGHT*! WHAT DO I DO?

I DON'T KNOW. I'M JUST HERE FOR ETHICAL PROBLEMS!

DON'T LOOK AT *ME*! YOU NEVER LISTEN TO WHAT *I* SAY ANYWAY!

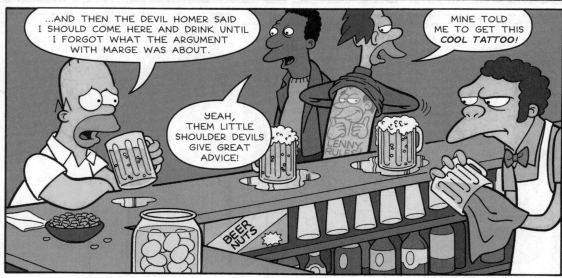

...AND THEN THE DEVIL HOMER SAID I SHOULD COME HERE AND DRINK UNTIL I FORGOT WHAT THE ARGUMENT WITH MARGE WAS ABOUT.

YEAH, THEM LITTLE SHOULDER DEVILS GIVE GREAT ADVICE!

MINE TOLD ME TO GET THIS *COOL TATTOO*!

BEER NUTS

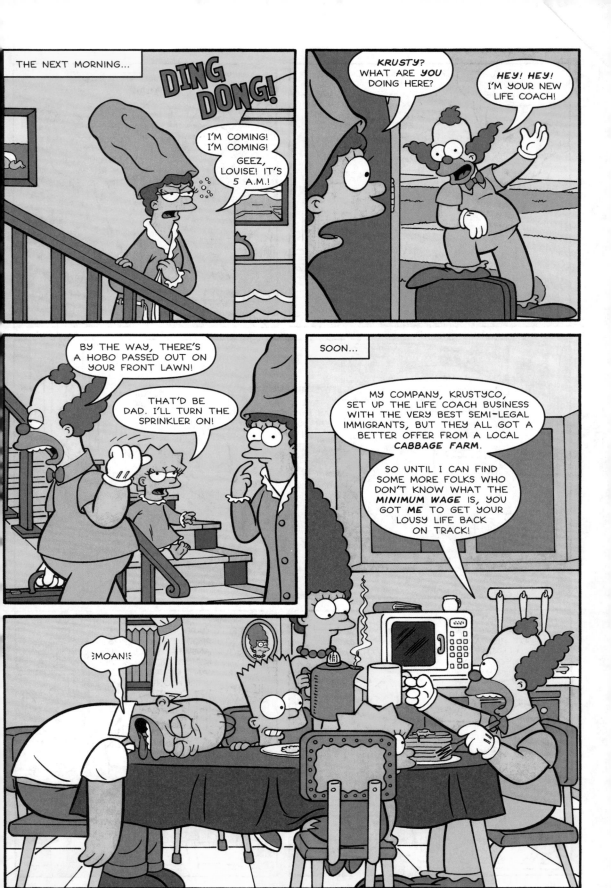

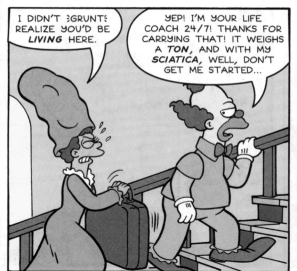

I DIDN'T ⸨GRUNT⸩ REALIZE YOU'D BE *LIVING* HERE.

YEP! I'M YOUR LIFE COACH 24/7! THANKS FOR CARRYING THAT! IT WEIGHS A *TON*, AND WITH MY *SCIATICA*, WELL, DON'T GET ME STARTED...

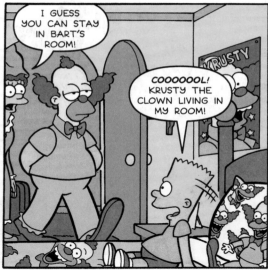

I GUESS YOU CAN STAY IN BART'S ROOM!

COOOOOOL! KRUSTY THE CLOWN LIVING IN MY ROOM!

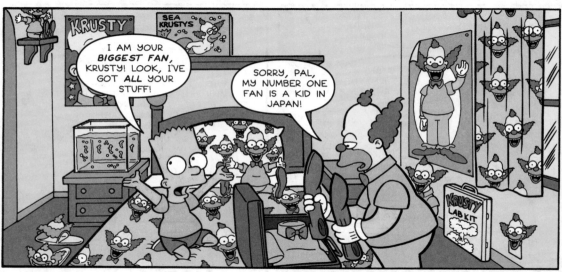

I AM YOUR *BIGGEST FAN*, KRUSTY! LOOK, I'VE GOT *ALL* YOUR STUFF!

SORRY, PAL, MY NUMBER ONE FAN IS A KID IN JAPAN!

HE HAS ALL MY PRODUCTS, *AND* HE GOT HIS PARENTS TO TURN THEIR HOME INTO A *KRUSTY SHRINE!*

YOU WANNA BE *NUMBER ONE?* YOU GOTTA TOP *THAT!*

HOMER, CAN I USE YOUR CREDIT CARD TO BUY MORE KRUSTY PRODUCTS ON *EBUY?* IF YOUR ANSWER IS YES, JUST GROAN LIKE YOU'RE HUNGOVER AND WANT ME TO LEAVE YOU ALONE!

⸨GROAN⸩

THANKS!

124

THE NEXT DAY...

NOW THE **MOST IMPORTANT THING** I CAN TEACH YOU IS MAKING THE MOST OF YOUR LIFE BY EMBRACING YOUR **INNER CLOWN.**

WELL, I DON'T KNOW, I'VE NEVER BEEN THE FUNNIEST MEMBER OF THE FAMILY.

MARGE! WE NEED A NEW **TOILET!**

SEE?

FOR NOW, WE'LL FOCUS ON THESE KEY AREAS OF YOUR LIFE.

LET ME INTRODUCE YOU TO YOUR NEW BEST FRIEND WHO'LL **SPICE UP** ALL THREE!

ROMANCE

HOME-MAKING

PARENTING

SELTZER!

HOMEMAKING...

THIS SELTZER REALLY GETS HOMER'S BEER AND SWEAT STAINS OUT OF THE COUCH!

SPRITZ!

PARENTING...

BART! THOSE COOKIES ARE FOR THE SCHOOL BAKE SALE!

YAAAAH!

SPRITZ!

ROMANCE...

THIS SCENE HAS BEEN CENSORED. TRUST ME, IT'S FOR THE BEST. I'VE SEEN IT, AND I STILL HAVE TROUBLE KEEPING FOOD DOWN.
--EDITOR BILL

THE NEXT DAY...

DING DONG!

AGAIN WITH THE MORNING VISITORS!

OH...HELLO, SOPHIE!

HI, SORRY TO BOTHER YOU. IS MY DAD HERE?

KRUSTY, IT'S FOR YOU!

IF IT'S THE *IRS*, YOU'RE MY *WIFE* AND I'VE ADOPTED *HOMER* AS A *DEDUCTION!*

SOPHIE!

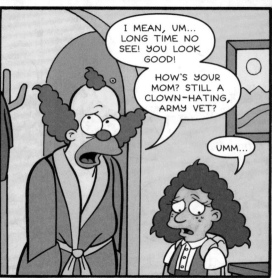

I MEAN, UM... LONG TIME NO SEE! YOU LOOK GOOD!

HOW'S YOUR MOM? STILL A CLOWN-HATING, ARMY VET?

UMM...

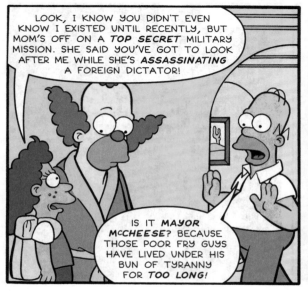

LOOK, I KNOW YOU DIDN'T EVEN KNOW I EXISTED UNTIL RECENTLY, BUT MOM'S OFF ON A *TOP SECRET* MILITARY MISSION. SHE SAID YOU'VE GOT TO LOOK AFTER ME WHILE SHE'S *ASSASSINATING* A FOREIGN DICTATOR!

IS IT *MAYOR McCHEESE?* BECAUSE THOSE POOR FRY GUYS HAVE LIVED UNDER HIS BUN OF TYRANNY FOR *TOO LONG!*

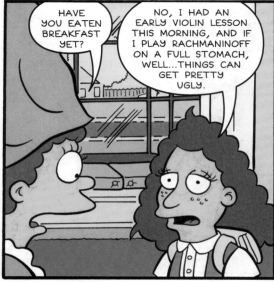

HAVE YOU EATEN BREAKFAST YET?

NO, I HAD AN EARLY VIOLIN LESSON THIS MORNING, AND IF I PLAY RACHMANINOFF ON A FULL STOMACH, WELL...THINGS CAN GET PRETTY UGLY.

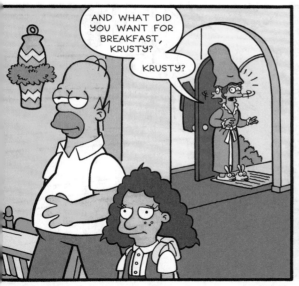

AND WHAT DID YOU WANT FOR BREAKFAST, KRUSTY?

KRUSTY?

KRUSTY? ARE YOU *HYPER-VENTILATING*?

PANT!

WHEEZE!

¡GASP!¡

NO, I'M THE UNKNOWN COMIC, AND I THOUGHT THE TIME WAS RIGHT FOR A COMEBACK!

I'M SORRY, I JUST GET SO *NERVOUS* AROUND SOPHIE. I'VE BEEN OUT OF THE PICTURE FOR HER WHOLE LIFE. WHAT COULD WE POSSIBLY *HAVE IN COMMON*?

I CAN'T BELIEVE *YOU'D* BE NERVOUS AROUND A CHILD. YOU ENTERTAIN *MILLIONS* OF THEM EVERY-DAY.

MILLIONS ARE EASY. GETTING THROUGH TO THE *ONE KID THAT MATTERS* ...THAT'S *HARD*!

MAYBE I JUST GOTTA ACCEPT THAT I'M DESTINED TO BE A *DEADBEAT DAD*.

OH, KRUSTY, YOU'LL FIND A WAY TO *CONNECT* WITH SOPHIE. YOU'RE *NOT* A DEADBEAT DAD!

UH...IS MILHOUSE HERE? I WANTED TO BORROW SOME MONEY FROM HIM TO BET ON A COCKFIGHT!

NOW *THAT'S* A DEADBEAT DAD!

LATER...

THIS IS WONDERFUL. A GIRL MY AGE WHO'S *ALSO* A MUSICIAN.

I'M SURE WE'LL BE *BEST FRIENDS*.

NO WAY, LIS! BUDDYING UP WITH KRUSTY'S DAUGHTER WILL MAKE *ME* HIS NUMBER ONE FAN AGAIN!

YOU CAN'T JUST *USE* HER LIKE THAT!

I CAN'T *NOT* USE HER LIKE THAT!

F.Y.I., WHILE YOU TWO WERE ARGUING, I ATE YOUR BREAK-FASTS!

D'OH!

THAT NIGHT...

C'MON, KRUSTY, YOU CAN *DO* THIS. THINK OF SOMETHING YOU HAVE IN COMMON. SOMETHING *YOUNG* AND *HIP*!

HEY! HEY!

SO, UM...IS IT JUST ME OR HAS "LITTLE HOUSE ON THE PRAIRIE" GOTTEN TOO PREACHY LATELY?

I DON'T KNOW. MOM DOESN'T LIKE ME WATCHING TV. SHE SAYS, "IT CAN LEAD TO DATING CELEBRITIES, AND THEY'RE ALL A BUNCH OF LOWLIFE, BOOZING, FLOPPY SHOE-WEARING DEGENERATES!"

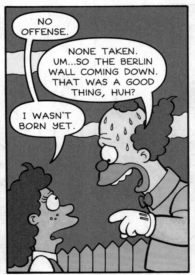

NO OFFENSE.

NONE TAKEN. UM...SO THE BERLIN WALL COMING DOWN. THAT WAS A GOOD THING, HUH?

I WASN'T BORN YET.

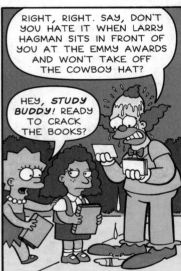

RIGHT, RIGHT. SAY, DON'T YOU HATE IT WHEN LARRY HAGMAN SITS IN FRONT OF YOU AT THE EMMY AWARDS AND WON'T TAKE OFF THE COWBOY HAT?

HEY, *STUDY BUDDY*! READY TO CRACK THE BOOKS?

YOU'RE BUSY. I SHOULD GET OUT OF YOUR HAIR!

BUT...

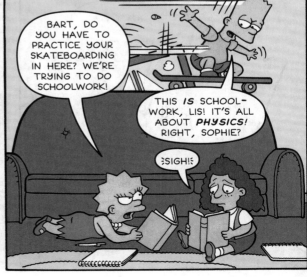

BART, DO YOU HAVE TO PRACTICE YOUR SKATEBOARDING IN HERE? WE'RE TRYING TO DO SCHOOLWORK!

THIS *IS* SCHOOL-WORK, LIS! IT'S ALL ABOUT *PHYSICS*! RIGHT, SOPHIE?

≶SIGH!≶

THE NEXT DAY AT SCHOOL...

GIRL'S WASHROOM

SORRY MY BROTHER'S BEING SUCH A PEST!

OH, HE'S NOT SO BAD. AND YOUR FOLKS ARE GREAT. THEY REALLY SEEM TO *CARE* ABOUT YOU.

AT LEAST BART CAN'T FOLLOW US IN *HERE*.

HI! I'M *BARTINA*, A NEW EXCHANGE STUDENT FROM SHELBYVILLE. SO WHAT ARE WE GIRLS TALKING ABOUT TODAY? MALIBU STACYS? BOYS? *CONTROLLING OUR COOTIES*?

AAAAAARGH!

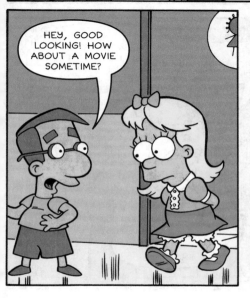

HEY, GOOD LOOKING! HOW ABOUT A MOVIE SOMETIME?

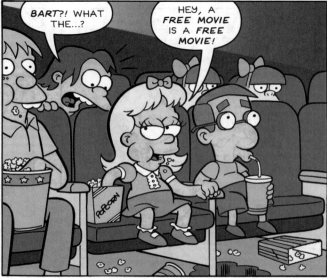

BART?! WHAT THE...?

HEY, A *FREE MOVIE* IS A *FREE MOVIE!*

THE NEXT MORNING...

≥YAAAAWN!≤

CLICK!

AAAAAAAH!

WHAT DID YOU *DO* TO ME?

≥YAWN!≤

YAAAAA!

OH, I DYED YOUR HAIR AND APPLIED SOME CLOWN MAKEUP LAST NIGHT. MAN, YOU'RE A *SOUND SLEEPER!*

IT'S ALL PART OF *AWAKENING* YOUR *INNER CLOWN!*

HOW DO I GET THIS *OFF*?!!

OH, IT'S THE *GOOD* STUFF! PARISIAN MIME-STRENGTH. THAT WON'T COME OFF FOR AT LEAST A WEEK!

BUT I HAVE TO DO THE GROCERY SHOPPING!

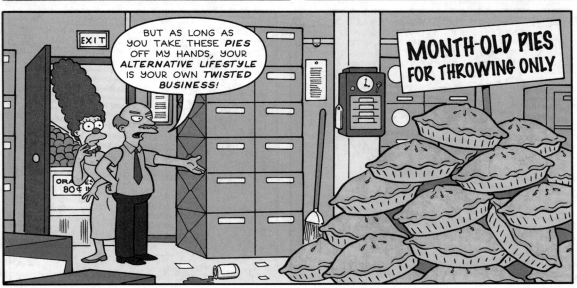

133

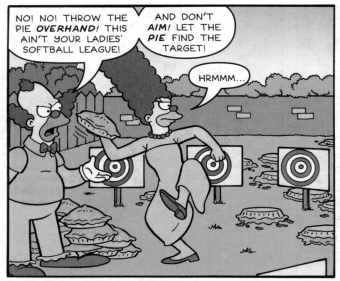

NO! NO! THROW THE PIE *OVERHAND*! THIS AIN'T YOUR LADIES' SOFTBALL LEAGUE!

AND DON'T *AIM*! LET THE *PIE* FIND THE TARGET!

HRMMM...

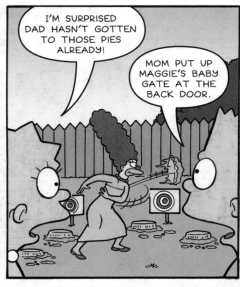

I'M SURPRISED DAD HASN'T GOTTEN TO THOSE PIES ALREADY!

MOM PUT UP MAGGIE'S BABY GATE AT THE BACK DOOR.

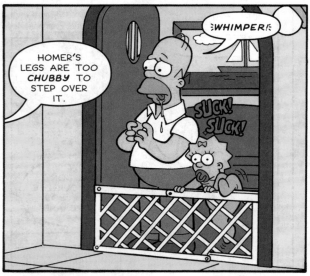

HOMER'S LEGS ARE TOO *CHUBBY* TO STEP OVER IT.

≀WHIMPER≀

SUCK! SUCK!

KRUSTY, I DON'T SEE HOW THIS IS HELPING ME BREAK OUT OF MY RUT! IT'S JUST A WASTE OF TIME, AND I'M SORRY, BUT I...

OH, HEY THERE! NO ONE WAS ANSWERING YOUR FRONT DOOR, AND I KNEW YOU WOULDN'T WANT TO MISS OUT ON A CHANCE TO BUY YOUR OWN SUCK-A-MATIC 3000 VACCUM CLEANER!

I'M *NOT* INTERESTED!

AW, THAT'S BECAUSE YOU HAVEN'T SEEN THE OLD GIRL IN ACTION.

TAKE OL' GIL'S WORD FOR IT! IF *I'M* SELLING YOU A VACUUM, IT *REALLY SUCKS*!

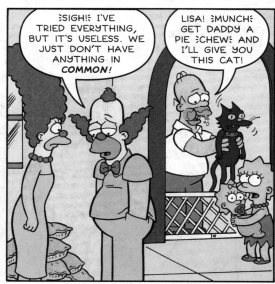

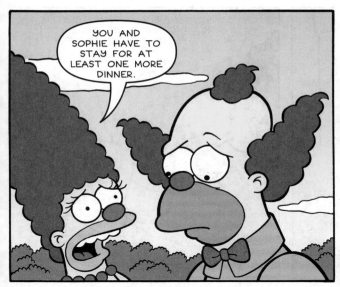

YOU AND SOPHIE HAVE TO STAY FOR AT LEAST ONE MORE DINNER.

WELL... OKAY.

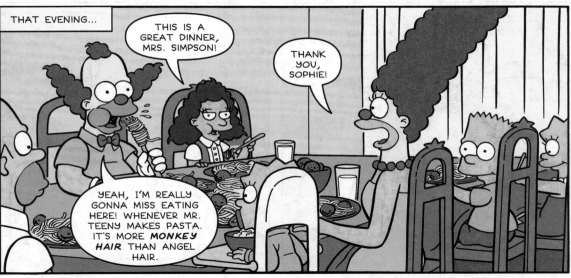

THAT EVENING...

THIS IS A GREAT DINNER, MRS. SIMPSON!

THANK YOU, SOPHIE!

YEAH, I'M REALLY GONNA MISS EATING HERE! WHENEVER MR. TEENY MAKES PASTA, IT'S MORE *MONKEY HAIR* THAN ANGEL HAIR.

EEEEW!

THAT IS *SO* COOL. MOM CAN WE GET A *MONKEY CHEF?*

YOU KNOW WHAT WOULD REALLY HIT THE SPOT FOR DESSERT? *WEEK-OLD PIE!*

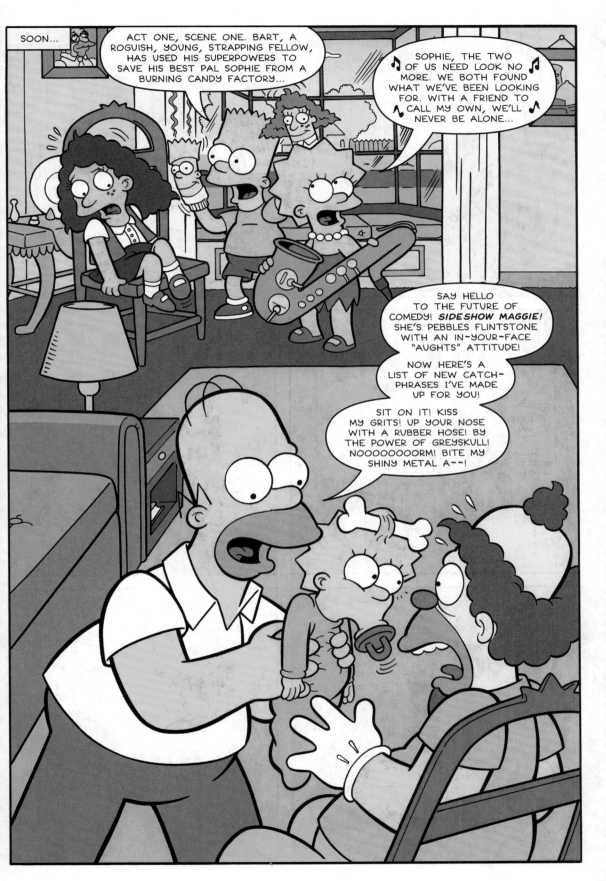

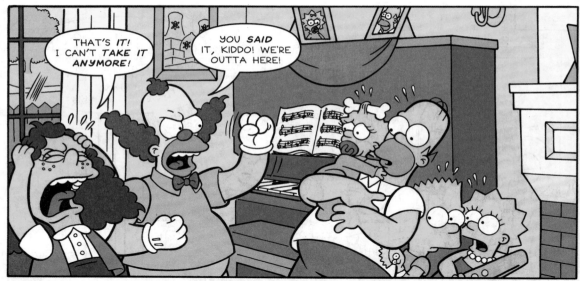

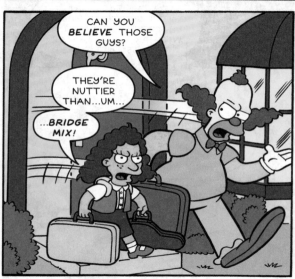

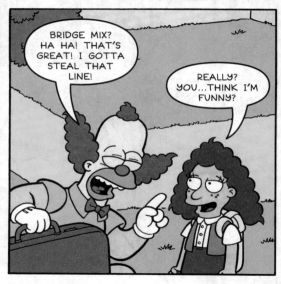

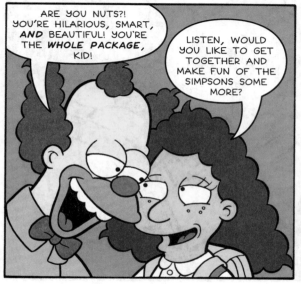

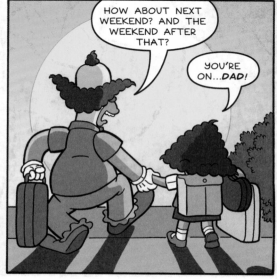

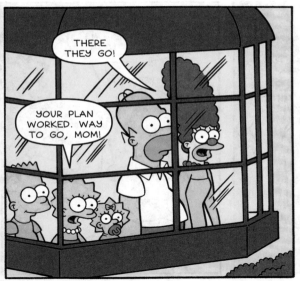

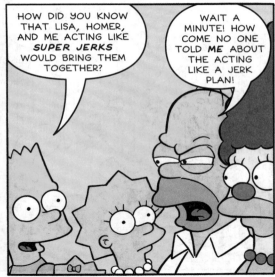

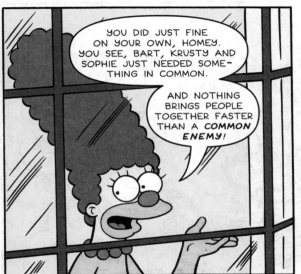

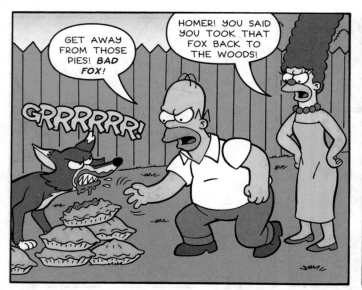

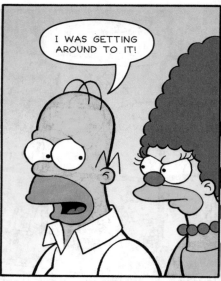

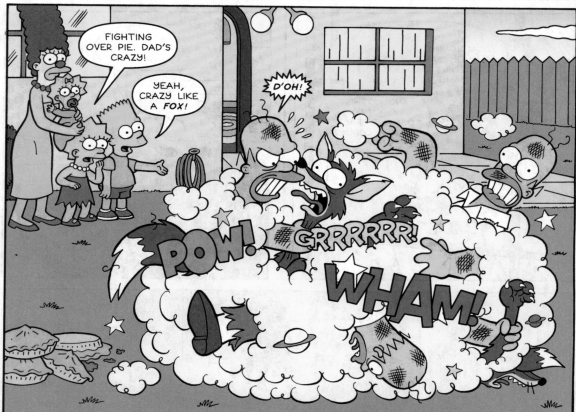

JOIN US NEXT MONTH, TRUE BELIEVERS, FOR THE PULSE POUNDING CONCLUSION OF THE FIGHT OF THE CENTURY,

HOMER VS. THE FOX!

WHO WILL GET THE PIE? THE PORTLY PARENT OR THE VICIOUS VULPE?

COME TO THINK OF IT, THAT DOESN'T SOUND GOOD AT ALL. OKAY, FORGET THE WHOLE FOX FIGHT THING. WE'LL COME UP WITH SOMETHING ELSE FOR NEXT ISSUE. IT'LL BE GOOD THOUGH, WE PROMISE. MAYBE WITH MONKEYS. HOMER FIGHTING A MONKEY? PEOPLE LIKE MONKEYS, RIGHT? --BILL